IMAGES
of America

GOSHEN

Our Hometown - Goshen!

David P. Cameron

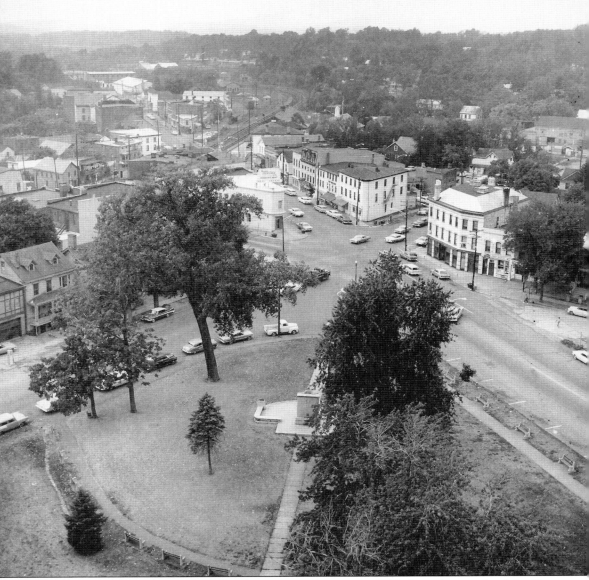

This view of the park and Harriman Square was taken in the 1960s from the steeple of the First Presbyterian Church.

On the cover: The Handy Corner Stationery Store was owned by I. C. Baldwin, who was also editor of the newspaper the *Independent Republican*, where he worked for 22 years in various capacities. Baldwin also served as town clerk from 1897 to 1904. He started the Handy Corner Stationery Store in 1901, where he sold newspapers, magazines, books, stationery, pens, and inks. The building was also the site of a grocery store and a dress shop. For the past 50 years, it has been the location of Howell's Café and Pantry restaurant. (Author's collection.)

IMAGES
of America

GOSHEN

Edward P. Connor

ARCADIA
PUBLISHING

Published by Arcadia Publishing
Charleston SC, Chicago IL, Portsmouth NH, San Francisco CA

Printed in the United States of America

Library of Congress Catalog Card Number: 2007920906

For all general information contact Arcadia Publishing at:
Telephone 843-853-2070
Fax 843-853-0044
E-mail sales@arcadiapublishing.com
For customer service and orders:
Toll-Free 1-888-313-2665

Visit us on the Internet at www.arcadiapublishing.com

*This book is dedicated to my sister Margaret Valerie Gugliotta
and to my parents, Valerina and John E. Connor, who loved Goshen.*

CONTENTS

ACKNOWLEDGMENTS

Compiling this book has been a great experience. A local history book cannot be written without the help of many historians and writers of the past. Recognition must be given to Samuel W. Eager, Russel Headley, E. M. Ruttenber, L. H. Clark, Elizabeth Sharts, Mildred Parker Seese, T. J. V. Cullen, and Henry Pomares. I thank them for allowing me to pass on their knowledge to a new generation. Thanks also to the many Goshenites who contributed to the advancement of local lore. It was great to hear all the stories of what was where and who worked and lived where. Special thanks are due to the Goshen Public Library and Historical Society for allowing me access to their great photographic collection. Ann Roche, Jamie Kehoe, and the staff of the library were always available to help. Without the help and computer knowledge of Diane Petit this book might not have made it into print. Richard Ayres was a great help in the scanning of slides used to create some of the photographs. I am also grateful to Dr. Claire Leonard for her help and support in making this book possible. Town and village historian Michelle Figliomeni's help and knowledge was invaluable. I would also like to thank the people of Goshen who have supported historic preservation over the years. Goshen has lost many fine homes and buildings, but the renewed appreciation and revitalization of our town and village in recent years will assure that Goshen remains a special place.

INTRODUCTION

Situated in the heart of Orange County, the town and village of Goshen are located approximately 60 miles north of New York City. Goshen was originally part of what was known as the Wawayanda Patent, dating from 1703. The first settler was Christopher Denne, who arrived in 1712. According to Samuel W. Eager's 1846–1847 *An Outline History of Orange County,*

> "The proprietors laid out the Village of Goshen by running a broad street or avenue, nearly north and south through the plot, some half a mile in length, and then by laying off four lots of eighty acres each, on the east and west sides of it. The village, most probably, was laid out within a few years after 1703 the date of the patent . . . 1714, for we have seen deeds for the lots in the village plot record, dated as early as the latter period."

Within the village is the Church Park Historic District that encompasses not only the center of the village but also includes the residential area of large Victorian homes of South Church and South Streets. Being rich in architectural treasures, Goshen is fortunate to have unique homes throughout the village and a number of early homesteads throughout the town.

Goshen is well-known for its roots in harness racing. The village is home to the Harness Racing Museum and the Hall of Fame of the Trotter. Historic Track is the oldest active harness track in the United States, having seen racing since 1838. Historic Track is on the National Register of Historic Places. Another track, now gone, known as Good Time Park, was a mile-long racetrack and home of the Hambletonian harness race. The Hambletonian harness race that was run every summer in Goshen from 1930 to 1956, before moving to Illinois, is now run at the Meadowlands in New Jersey.

As the county seat, one of the main sources of employment today, as it always has been, is the county government. An area along Main Street, within the historic district, where many lawyers have their offices is known as Lawyers' Row. The area contains fine examples of 19th century townhouse architecture.

Some relatively famous names from Goshen's past include Gen. James W. Wilkin, speaker of the New York State Assembly; Dr. Benjamin Tustin, one of the first doctors to experiment with the use of vaccines; and Horace Pippin, the African American painter, who lived and painted in the village. Anna Dickerson, an anti-slavery activist, and jazz musician Willie "the Lion" Smith also called Goshen home.

The goals of this book are two-fold to show our new residents what was where and to give long-time residents the opportunity to reminisce about Goshen's past.

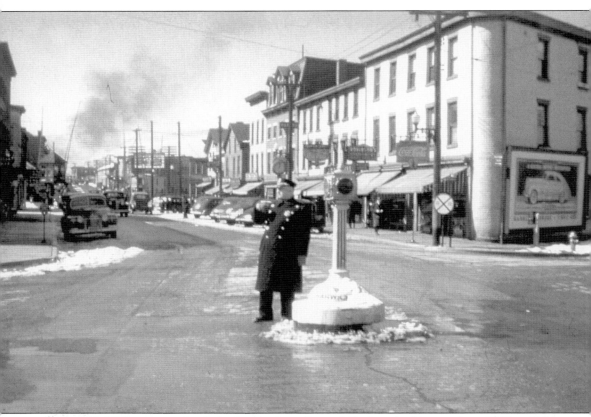

Robert "Bob" Bruce was chief of police in the village of Goshen for 34 years from 1915 to 1949. Chief Bruce was also drum major for the Goshen Fife, Drum, and Bugle Corps. Former police chiefs also include Stanley Golemboski, Fred Walker, and John Egbertson. The base of the traffic signal, seen in the photograph, is used today as the base of the flagpole at Maplewood, the village hall. The Village of Goshen Police Department was organized January 1, 1876.

One

HARRIMAN SQUARE AND
MAIN STREET

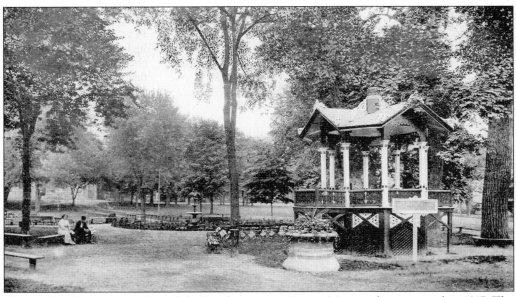

Church Park had two bandstands before the current Everett Memorial was erected in 1917. The first bandstand was built in 1855. About 1876, the bandstand in the photograph was constructed for the popular Thursday night band concerts that lasted well into the 1940s. The flower planter in the photograph was originally used as the second horse fountain near the area of the current Harriman Memorial Fountain.

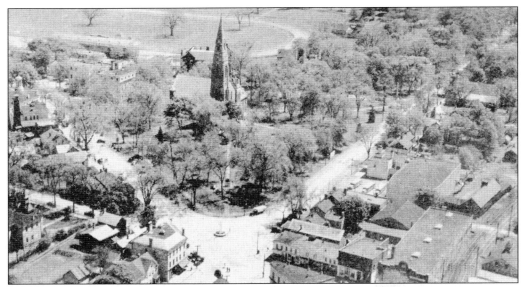

This aerial view of Harriman Square, commonly referred to as the square, shows the First Presbyterian Church and Historic Track. Church Park is part of the original nine-acre plot designated for public use in a town deed of 1721. The park assumed its current triangular shape when Main Street was cut through from the Orange County 1841 Court House to the square for a more direct route to the railroad that was located near the current Village of Goshen Police Station.

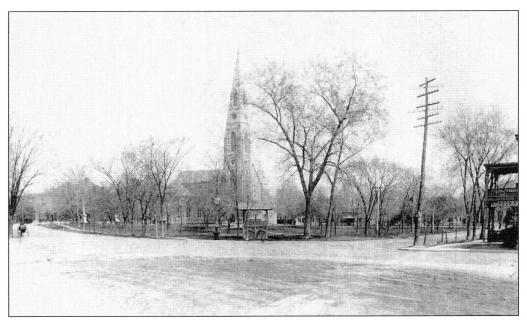

This early view of Harriman Square, then known as Park Square, shows the First Presbyterian Church and the first bandstand built in 1855. This photograph predates the installation of the Harriman Memorial Fountain in 1911. The first horse trough with a light on top is to the left of the bandstand.

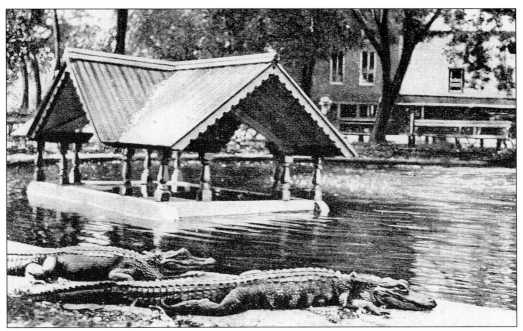

The alligators in the fountain were brought to Goshen around 1900 by Mayor Robert Hock, who owned the St. Elmo Hotel that was on the site of the current post office. The alligators wintered in tanks in the basement of the hotel. The alligators were a part of the park scene until 1916, when the fountain was replaced by the Everett Memorial in 1917.

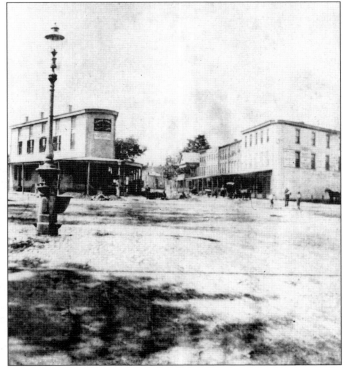

Erected in 1875, the first horse fountain is seen in this view of Harriman Square. The flat iron building on the left was then known as the Fletcher block. A meat market was on the first floor, and a fish market was in the basement. The building was the location of the Goshen Savings Bank, organized in 1871. Dickerson and Meany Insurance had offices on the second floor in more recent years. This is an L. Hensel stereoscopic view taken in 1876.

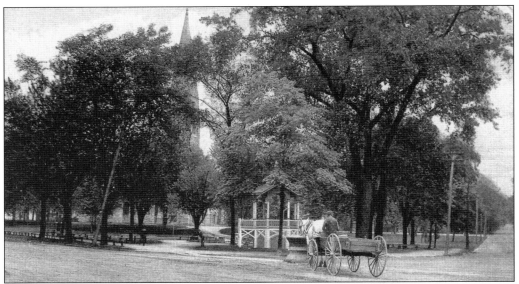

A horse and wagon are at the second known horse trough, and the 1876 bandstand is in the background in this view of the location known over the years as Park Square, the square, and finally Harriman Square.

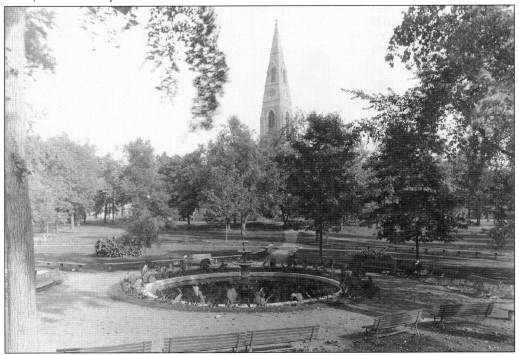

The fountain was erected in 1886 and served as a gathering spot, until it was replaced by the Everett Memorial in 1917. Mrs. M. P. Bradley, principal of the Young Ladies Seminary, was the driving force in getting the park area cleaned after the construction of the First Presbyterian Church. She raised the money to have the debris that had been sitting in the area removed and to create what became the park.

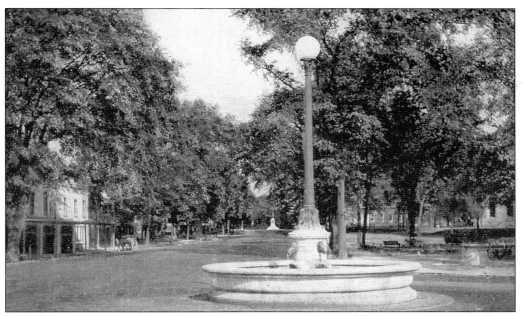

The Harriman Memorial Fountain on Park Square was designed by Frances Burrall Hoffman and was built by Charles Cary Rumsey, husband of Mary Harriman. In later years, the 1940s through the 1960s, when the fountain was no longer working, flowers were planted every summer and maintained by former police chief Stanley Golemboski. The fountain was restored, and its immediate area redesigned with additional plantings and benches in 1999.

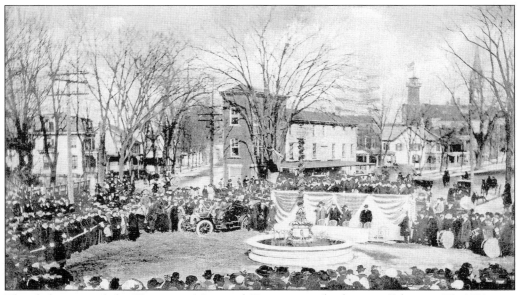

The dedication of the Harriman Memorial Fountain took place on February 25, 1911, two years after the death of Edward Henry Harriman. In 1964, Park Square was renamed Harriman Square by Mayor Henry Hopkins during the 250th anniversary celebration of the settlement of the Goshen area.

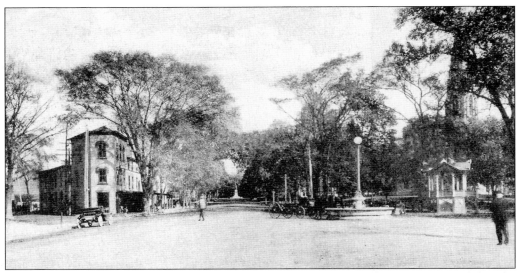

This view of Harriman Square shows the bandstand and Van Vliet's store on the left. The photograph was taken some time between the installation of the Harriman Memorial Fountain in 1911 and the yet-to-be-constructed Everett Memorial in 1917.

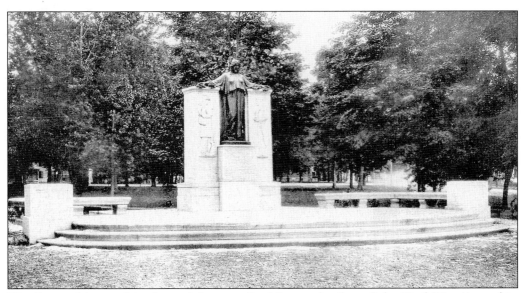

The Everett Memorial in the park honors all soldiers and sailors of the Civil War. Erected in 1917 at the corner of the park, it replaced the wooden bandstand, fountain, and pond that were there previously. Charles T. Everett was a long time civic leader and local banker who also left money for the construction of the Goshen Public Library and Historical Society in 1917–1918.

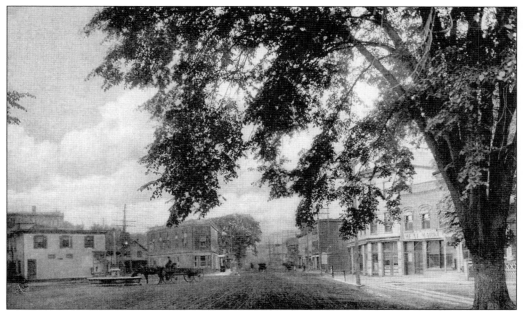

Looking toward West Main Street, Harriman Square before being paved shows a horse enjoying Harriman Memorial Fountain. The building to the left was demolished to make way for the current bank building. Glass's Meat Market on the right was there for years and was run by Fred Glass and his wife from the 1940s to the 1960s.

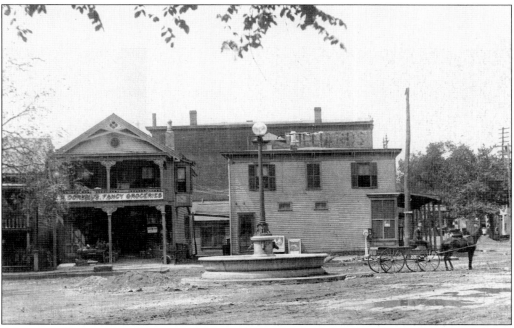

A horse and buggy passes Harriman Memorial Fountain with Doremus' Fancy Groceries store in the background. Frank H. Doremus started working in Goshen in 1884. He became proprietor of his grocery store in 1899. The store was previously owned by H. C. Horton and later by Jack McShane. The site is the location of the current bank on the square.

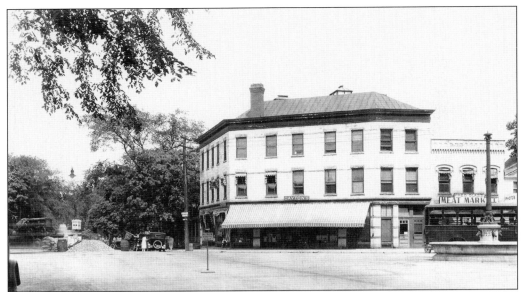

Dayton's was a dry goods or department store on Harriman Square for years. Later owned by Julia Maney, this store was where one could do everything from paying a utility bill to purchasing material and sewing needs. Fred Glass's Meat Market is to the right in the photograph.

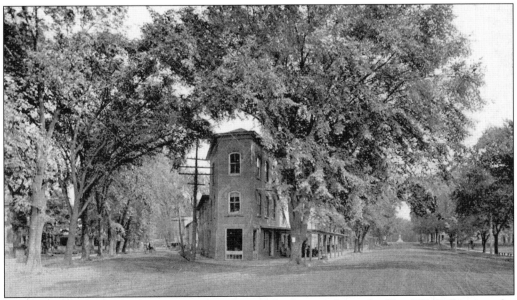

The above view of Main Street looking east from the Square shows the Van Vliet's Store on the left with its flatiron addition. In later years, the building became known as the Country Store building and housed Piggott's Vegetable Store and the Newburgh Evening News offices. The building was razed and replaced by the current flatiron structure built by Lawrence Meinwald and Raymond Quattrini. Note the large shade trees and Main Street before it was paved.

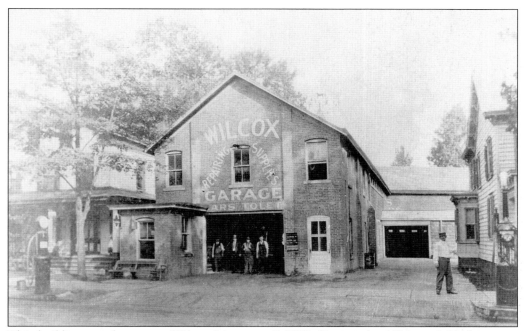

This building was known as Wilcox Livery until 1922. During the 1930s and 1940s, it was known as Banker and Sheehan, being operated by Dewey Banker. In more recent times, it was known as Heffner's Garage. The building was sold to Lawrence Meinwald and reconstructed as office space. The houses on each side of the building show the residential element that once existed on the square. They were demolished in the 1960s.

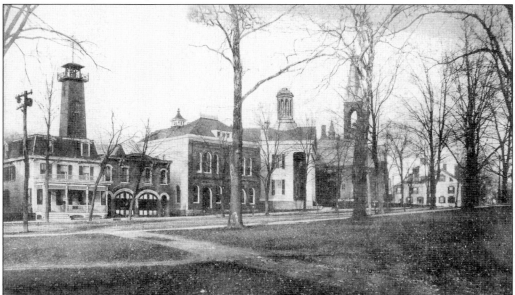

This view of the heart of the historic district on Main Street shows the Jonas house, which is now a deli, the former Cataract and Minisink firehouse, the Surrogate's court building, and the Orange County 1841 Court House. The Goshen United Methodist Church is next to the court house.

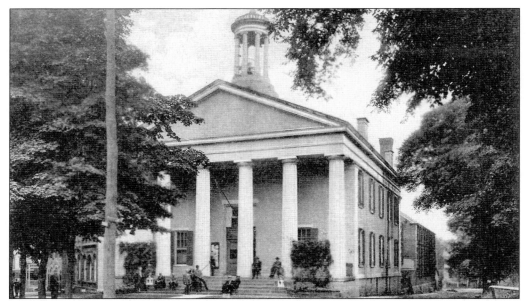

Designed by Thornton Macness Niven (1806–1875), this view shows the Orange County 1841 Court House on Main Street and Court Lane with the county jail in the rear. The jail was torn down in the 1960s when a new jail was built on Erie Street behind the current Orange County Government Center. The building to the left in the photograph was the Surrogate's Court building of Orange County. The interior of the courthouse was remodeled in 1895 and included the addition of tin walls and ceilings that remain today.

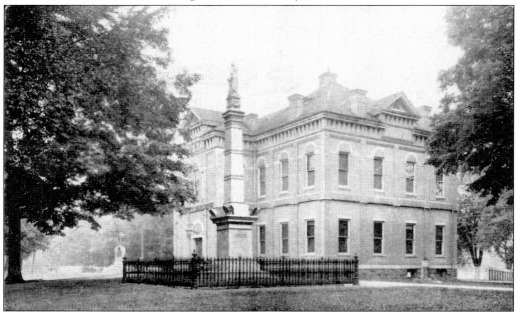

The County Building was first built in 1851 and then enlarged in 1887 and again in 1937 when a third floor was added. It held most county offices with the exception of the courts and jail, which were across the street. The monument in the photograph is a memorial to those who died at the Battle of Minisink in 1779. The monument was installed in 1862.

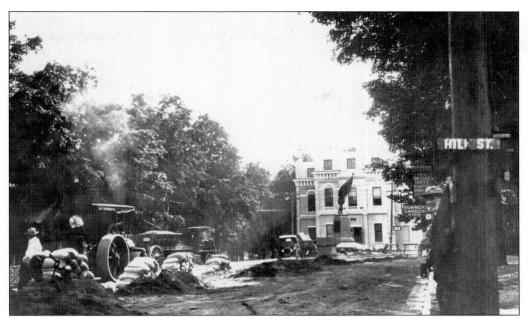

The activity on Main Street in front of the Orange Inn shows the concrete paving of the street in 1917. The Orange Blossoms Monument and the old 1887 County Building are in the background.

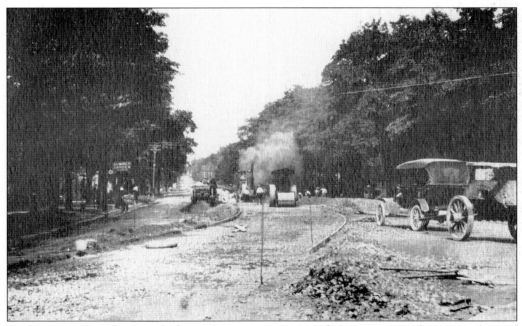

Looking east, this photograph shows the concrete paving of Main Street in the area in front of the Orange Inn and Lawyers' Row.

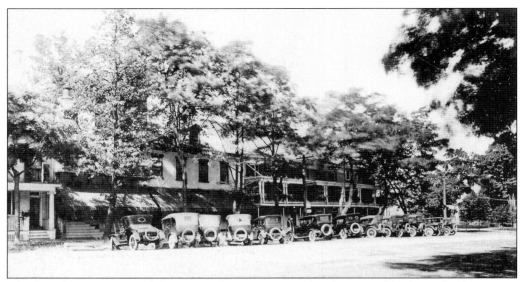

The Orange County Hotel, known as the Orange Inn, has been a public house back to "time when memory of man runneth not," and has had a long succession of proprietors. It stands upon the site of the first courthouse and jail of 1738. Today the building is the site of a successful restaurant.

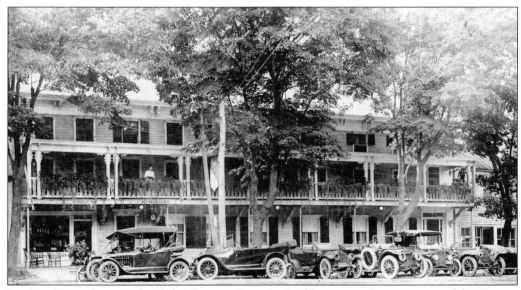

In the above photograph of the Orange Inn, the building next door was owned by Barney Clark, who ran a restaurant and grocery store. Clark's store was noted for oyster stew and a soda concoction he called Mountain Dew. The building was torn down in 1918 to straighten Hill Street and make room for the Goshen Public Library and Historical Society.

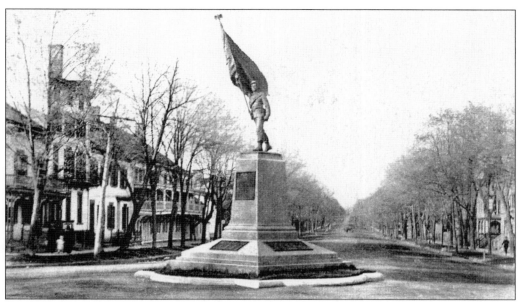

On Thursday, September 5, 1907, at the intersection of Main Street and Park Place, a monument was dedicated to the veterans of the Civil War 124th Regiment, known as the Orange Blossoms. The monument, which weighs 19 tons, has a bronze figure, *The Standard Bearer*, designed by Theo. Alice Ruggles Kitson. The figure is 18 feet in height and stands upon a pedestal of granite, which is 14 feet high. The monument was presented to the people of Orange County by Hon. Thomas W. Bradley of Walden, who was a member of Congress.

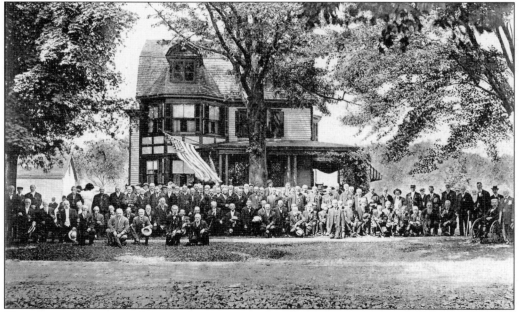

The above scene is a gathering of veterans at the 50th Anniversary of the 124th Civil War Regiment, the Orange Blossoms, in October 1912 on Murray Avenue. The Orange Blossoms left Goshen in 1862 with 1,282 soldiers. Only 283 were alive at the end of the war. The Victorian house is still standing.

The above view shows the base of the Orange Blossoms Monument about 1906–1907 on its way from the Erie Railroad station (currently the Village of Goshen Police Station) to its position on Main Street and Park Place. The photograph was taken at the square. The buildings in the background were demolished to make way for the bank building currently on the site.

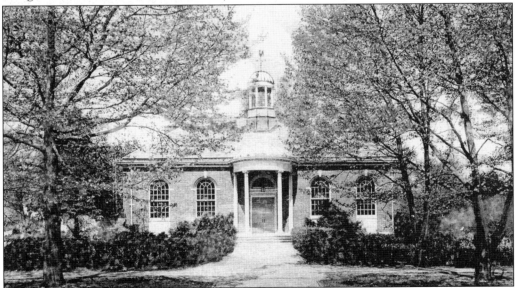

The first library was in the Farmers Hall Academy on the site of the present town hall. In 1794, the school trustees appointed the Reverend Nathan Ker librarian and ordered the library removed to his home. In 1831, a library association was organized, but quickly died out. The Goshen Library and Historical Society was incorporated July 6, 1894. It became a public library in 1911. Charles Everett donated the money for a new building in 1918, at a cost of $35,000. The small addition on the back was added in 1976. The library's official name was changed in 1984 to the Goshen Public Library and Historical Society in recognition of its service to the general public.

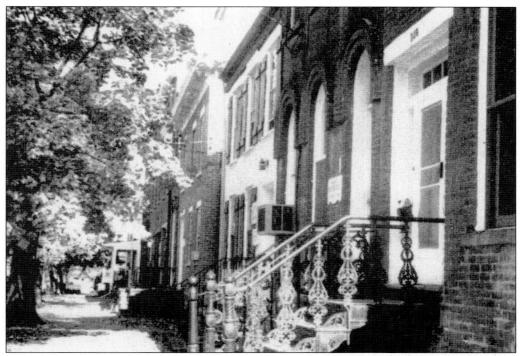

This area along Main Street was once the central business area of the village. With the arrival of the railroad in 1841, the business center moved west to the area near the current Village of Goshen Police Station. This area along Main Street is now known as Lawyers' Row, acknowledging the many law offices along the street.

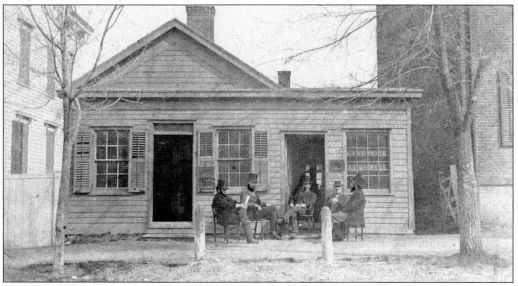

The Wilhue Law Office is pictured above. Seated in the photograph are J. I. Howell, Mr. Chaufion, Mr. Coleman, and Mr. Bacon. The exact location of this building is unknown, but it might have been along Main Street and Lawyers' Row. The brick building to the right in the photograph may still be standing.

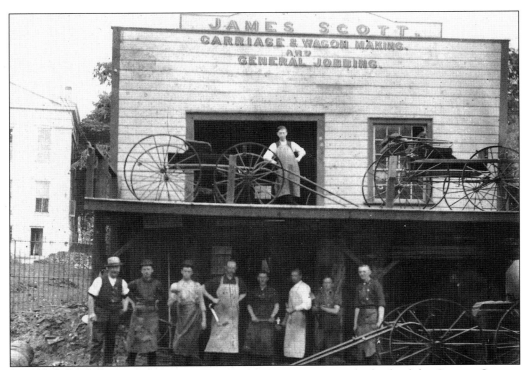

James Scott Sr.'s wagon shop was located on Webster Avenue. The back of the Orange County 1841 Court House is to the left. From the number of workers in the picture his business was a success. His son had a similar shop across the street.

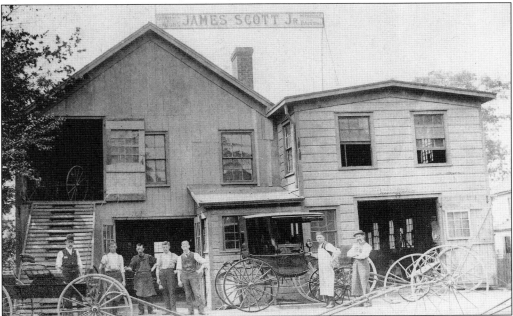

James Scott Jr. tried his hand at making and repairing horse sulkies. The building was also located on Webster Avenue and is no longer standing.

This house is located on Main Street across the street from the Goshen Public Library and Historical Society and Orange Inn. When Goshen was a summer vacation destination for the horse races, rooms were difficult to find. People rented rooms in their private homes, and there were a number of small hotels. Built around 1875, the house was owned by the Elston family. The sign over the porch reads "Rest Cottage."

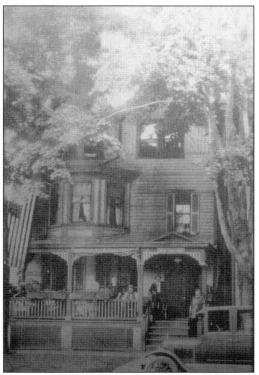

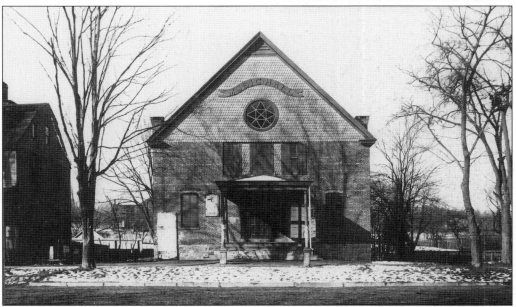

The popularity of the Goshen Vocal Society brought about the construction of this Greek revival Music Hall in 1889 to serve as an auditorium for musical and dramatic presentations. The photograph was taken in 1906. Note that Main Street is not paved and the Main Street High School is not yet constructed to the right in the photograph. The building has served for many years as the Masonic temple.

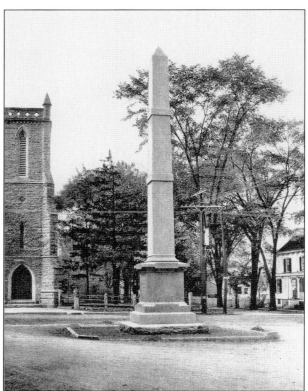

Located on South Church Street and Park Place stands a monument of native Pochuck granite erected to the memory of Henry Wisner, member of the First and Second Continental Congress by his great-granddaughter Frances Wisner Murray, widow of Ambrose Spencer Murray. The monument was dedicated on July 22, 1897, by Dr. John H. Thompson.

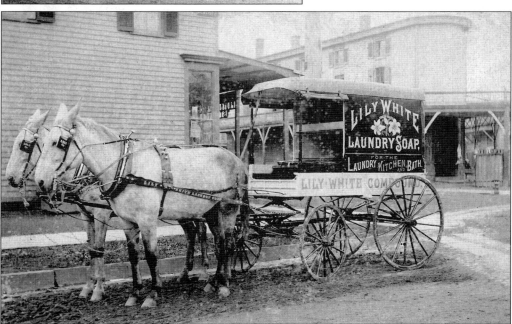

The Lily White Laundry Soap delivery wagon is parked on the corner of South Church Street and Greenwich Avenue. The building on the left was razed to make room for the Goshen Savings Bank.

Two

BUSINESS AND
TRANSPORTATION

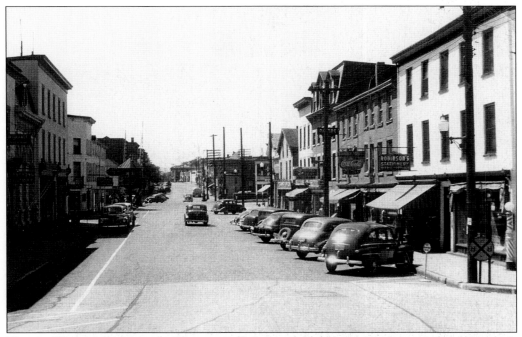

This is West Main Street looking west. Robinson's Stationery Store is on the right, with Lobdell's ice cream parlor next door. John Robinson established and ran the stationery store for almost 50 years. Margaret Gleasey started working there after school and acquired the business in 1946 from H. O. Tompkins. The store was a village meeting spot where people picked up their daily newspapers from assigned slots that had their name above the slot. Note the parking configuration of the cars facing into the curb.

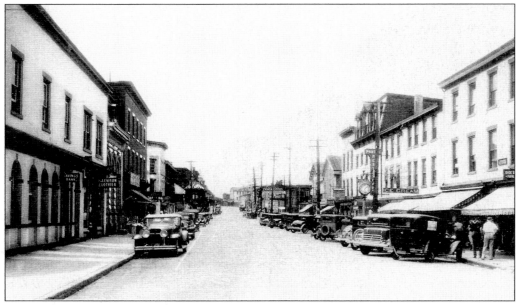

This earlier view of West Main Street looking west shows the clock in front of Lobdell's ice cream parlor. Markowitz's Grocery Store is on the left in the building where Howell's Café is currently located.

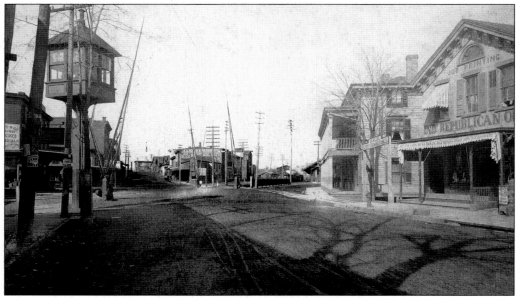

Seen here are the railroad gatehouse and the Independent Republican offices on the second floor in the building that later was the site of Strong's Pharmacy and is currently Baxter's Pharmacy. The building was also a jewelry store and a restaurant operated by James Tandine. The Occidental Hotel is on the right in the next building.

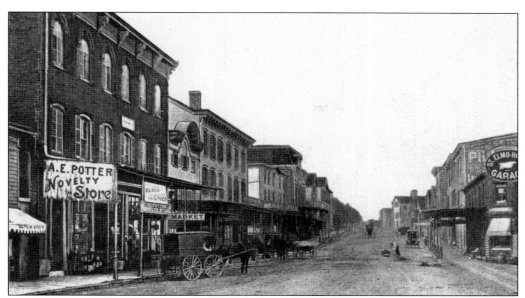

In this photograph of upper West Main Street, A. E. Potter's Novelty Store is on the left, occupying the site that is currently a vacant lot. This building once was the location of Barnes' Butcher Shop and the Tavern, later to be called Jack Benny's. The barbershop on the right occupying part of the current Elsie's Restaurant remained there into the 1970s. Elsie's Restaurant was called O'Henry's when Henry Mandato ran the restaurant. His father operated the barbershop. The photograph was taken before 1920.

Looking east toward Harriman Square, this very early photograph, probably taken around 1880, shows the Occidental Hotel on the left. West Main Street is still a dirt road and the railroad gatehouse has yet to be constructed. In 1866, kerosene oil street lamps were introduced. Gas lights came into use in 1879. In 1892, 100 electric streetlights were installed. Wood plank sidewalks were installed along West Main Street in 1849.

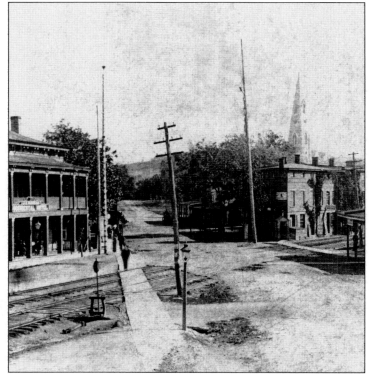

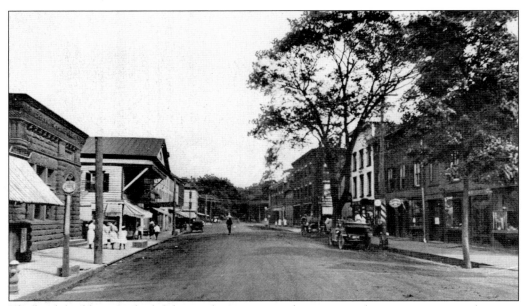

The bank building on the left has undergone many changes over the years, as seen in this view of West Main Street looking toward Harriman Square. Originally it was the Bank of Orange County, then was the National Bank of Orange County. The building on the left with the roof overhang served as the Grand Union and then Goshen Hardware. Note on the left the early street clock.

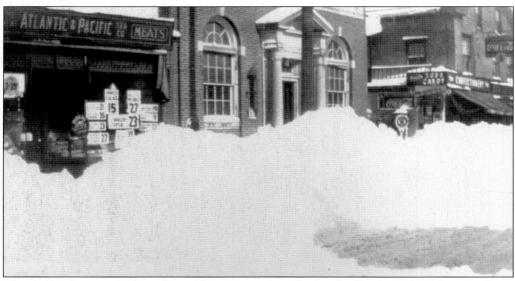

This 1930s photograph shows West Main Street when Goshen had both an A&P Grocery Store and a Grand Union. The photograph was taken after a major snow fall. The shadow in the snow is of the railroad gatehouse that was located across the street. Other small grocery stores were Benfante's, Markowitz's, Glebocki's, Rundle's, Foy's, and Wehinger's.

H. C. Horton and Company Provision Grocers was located on the square. This old country store had various owners over the years. It was the Doremus Grocery Store and was Jack McShane's store until the building was demolished to make room for the bank building now occupying the site.

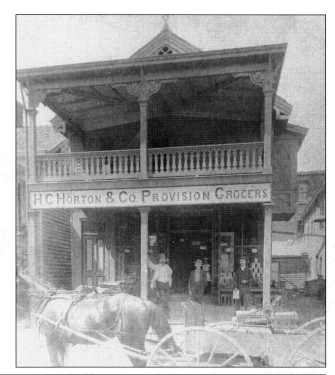

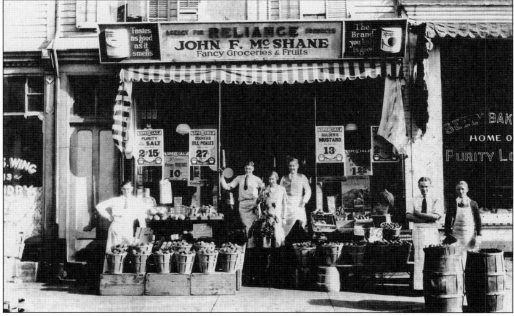

This is the McShane grocery store on Greenwich Avenue. McShane is standing in the doorway on the right. The store later became Arvanites Liquor Store. McShane moved around the corner to a building on the square that was a grocery store for many years, operating as H. C. Horton and Company Provision Grocers and Doremus' Grocery Store. McShane was still operating the store in the 1960s, until both buildings were razed to make room for the bank on the square.

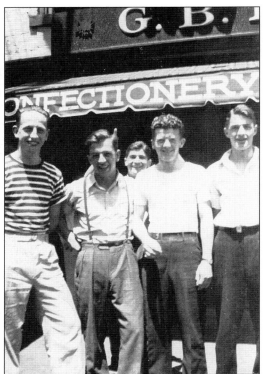

The "Lobdell Gang" is together in front of Lobdell's, the local ice-cream parlor, on West Main Street in the 1930s. Seen in the photograph, from left to right, are Clifford Ashman, Louis Shesa, Anthony Turi, John E. Connor, and Thomas Lane.

Ackerley's Confectionery Store and Ice Cream Parlor was where Joe Fix Its Bicycle Shop is today. George Ackerley is pictured behind the counter. It later became known as Lobdell's, a favorite spot for high school students in the 1930s and 1940s. Next door was Howell's Pantry before the Howell brothers moved across the street to the present location.

Farrell's tobacco shop was on the corner of West Main Street and Market Street in what was once known as the Drake block. The site was the Goshen Pharmacy for years and is now a coffee shop café. The location next door, the site of the Wonder Bar, became the post office after the previous post office was destroyed in the St. Elmo Hotel fire of 1920. Before being a post office, the site was a hotel.

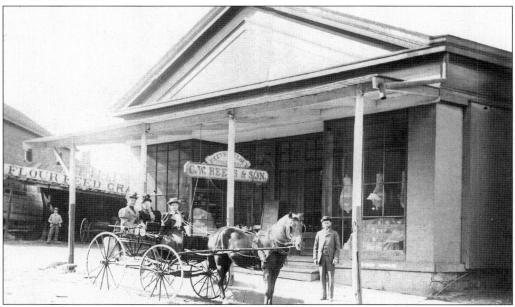

C. W. Reeves and Son operated on West Main Street in a building that was where the current parking lot for the Kennett's Gymnastics is presently located. The company became Reeves and Kelsey. In the photograph, Floyd H. Reeves (the son) is standing, and daughter Clara is driving. In the back seat are Floyd's wife Christine, and sister Hattie. Floyd and Christine built the beautiful Victorian house on the park next to the current Donovan Funeral Home in 1876. The building was for many years the James H. Anderson building supply store.

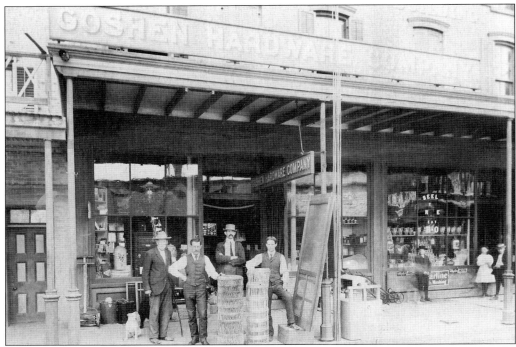

James G. Spier was the original owner of the hardware store located on West Main Street. In 1902, with Jay H. Newbury, Frank Hill bought the store and gave it the name Goshen Hardware. Years later, Joe Gargiulo bought the store and moved it to the former Grand Union building, near the former Hopkins Hardware store. In 1992, the Foley family bought Hopkins Hardware and now operates Goshen Hardware on the former Hopkins site.

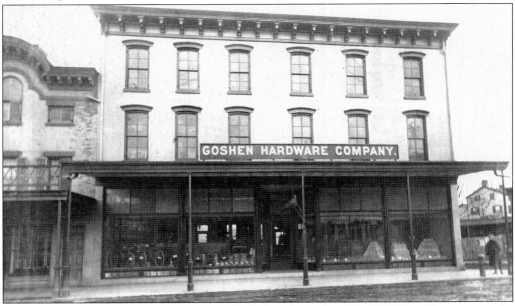

Goshen Hardware Store is seen here as it looked in the early 1900s. JAB Travel is now on the left side of the building and Farfalla Clock Company is on the right.

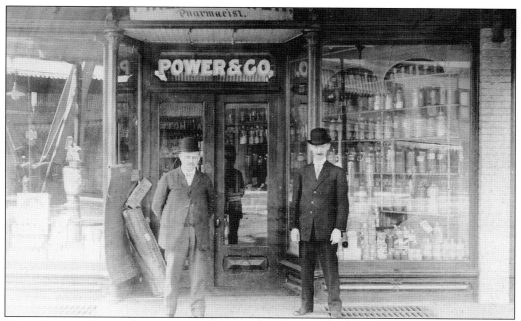

This photograph was taken in 1910. It shows pharmacist Philip Power on the left and Charles Scott on the right, standing in front of the drug store where the dress shop is currently on West Main Street. The drug store was later operated by Mary "Mae" Bassett. The store area became part of Wehinger's Food Market in the 1960s.

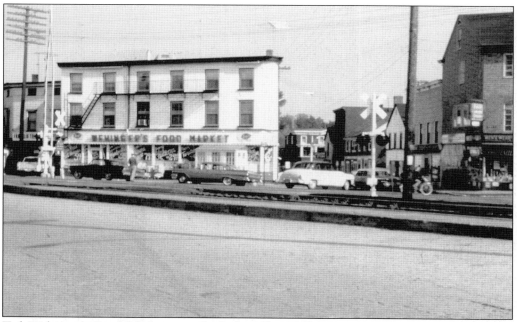

Ted Wehinger's Food Market as it looked in the 1960s is seen in the above photograph. The building underwent a major renovation in recent years when it was purchased by Lawrence Meinwald.

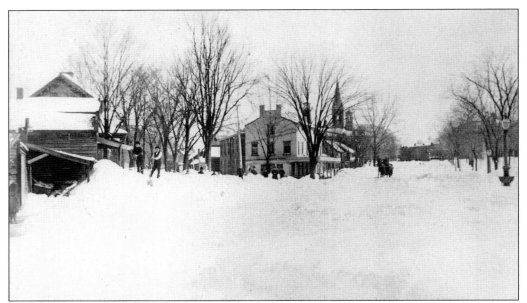

This scene, taken after the blizzard of 1888, is looking east up Main Street from the square. The building in the center of the photograph was Van Vliet's store before the triangular flatiron section was added. The building was razed in the 1990s and replaced by the current flatiron building. The first known horse trough, with the light above, is to the right. This was replaced by a round cement fountain and then by the current Harriman Memorial Fountain in 1911.

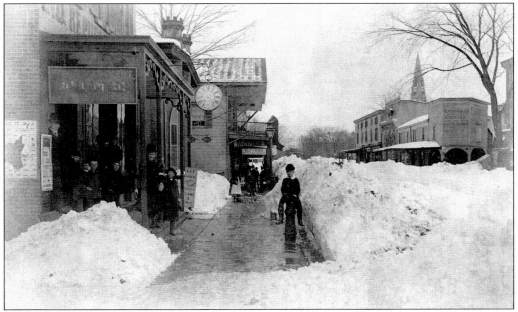

This view of the results of the blizzard of 1888 shows a boy sitting on a fire hydrant in front of what is now Baxter's Pharmacy. In years past, the building was the site of the Independent Republican offices, the A&P, and Strong's Pharmacy, which contained a popular soda fountain.

Looking west down West Main Street after the blizzard of 1888, the canopied walk ways are seen along the business district. The store Redfield and Millspaugh is on the right. The store later became Robinson's Stationery Store and a barber shop on the corner. Today it is the Goshen Gourmet Café. To the left in the photograph are wooden buildings that were replaced by the brick building that is now the home of Howell's Café.

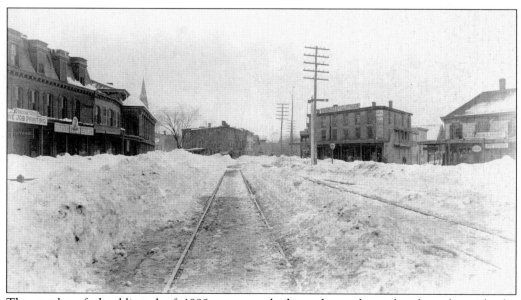

The results of the blizzard of 1888 are seen looking down the railroad tracks with the Howard "Zig" Samuel's clothing store in the building behind the electric and telephone pole. The St. Elmo Hotel and the Occidental Hotel are on the left.

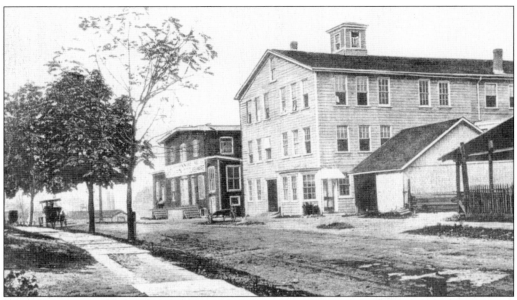

J. S. O'Connor established his American Rich Cut Glass factory during the early 1900s. Fine-cut glass was made in the building on West Main Street that is now the location of the Suresky and Son car dealership. The building that housed the Miller Road Cart Company next door was destroyed by a fire in 1939. Joseph Coates bought the Miller Road Cart Company in 1903, before opening his car manufacturing company on Greenwich Avenue in 1908.

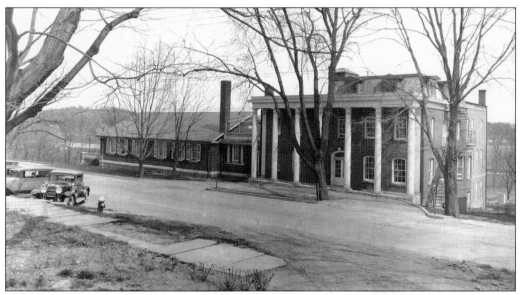

Goshen Emergency Hospital was organized in 1908. The hospital occupied four rooms in a building on West Main Street. Renamed the Goshen Hospital, it was located in this building on Greenwich Avenue that was formerly the home of Luella Morris Van Leuvan. She left the house to the hospital in 1915. Mr. and Mrs. Gates McGarrah and James B. Ford contributed money for additions to the house for the hospital. The building served the community until 1967 when Arden Hill Hospital was opened.

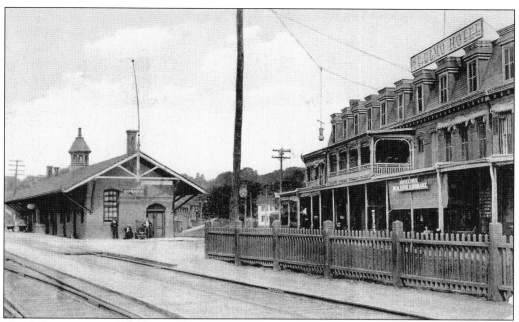

The Erie Railroad came to Goshen in 1841. The brick station was completed in February 1867 at a cost of $20,000. The original depot served from 1841 and was demolished in February 1867, after the opening of the brick station. The building now serves as the Village of Goshen Police Station.

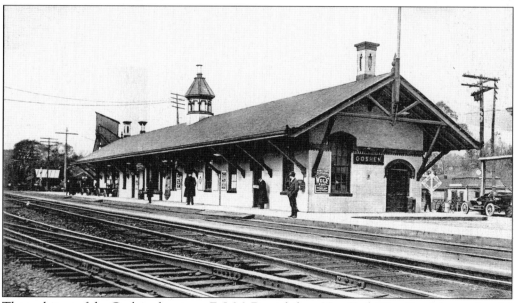

The architect of the Goshen depot was E. J. M. Derrick from New York City. Derrick was also the architect of Robert H. Berdell's home on Main Street, later to be known as the Interpines. The site is now occupied by the Orange County Government Center. The *Independent Republican* reported, "Those qualified to judge, pronounce it to be the best arranged, most elegantly finished and commodious of any depot upon the route of the Erie railway."

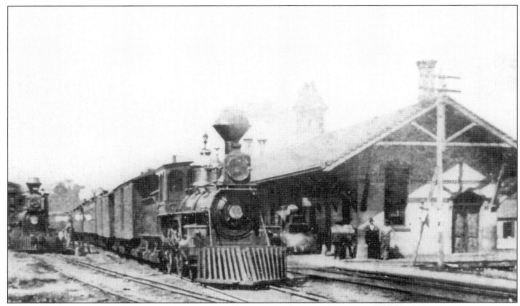

This photograph of a locomotive at the Erie station was taken about 1886. With the opening of the railroad, the business district gravitated to this area of the village from farther east on Main Street. This area that was to become West Main Street was raised to accommodate the building of the railroad.

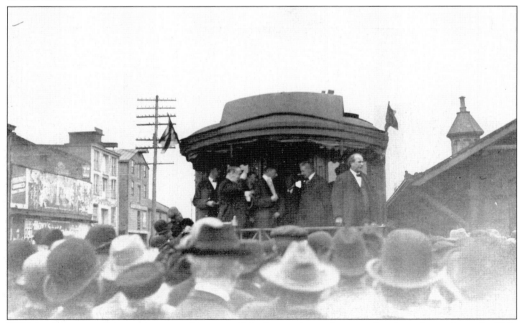

William Jennings Bryan is seen making a political speech to a large gathering of people at the Erie Railroad station, now the Village of Goshen Police Station. Bryan was a three-time Democratic party nominee for president of the United States. He was one of the most energetic campaigners in American history, inventing the national stumping tour for presidential candidates. His three failed presidential bids were in 1896, 1900, and again in 1908.

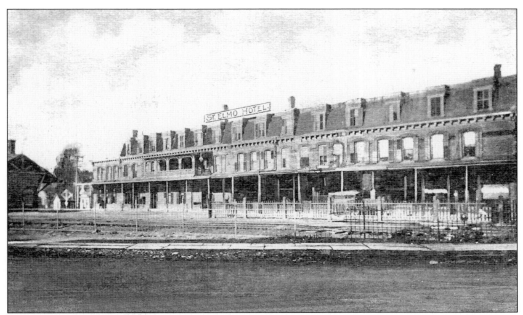

With 52 rooms, the St. Elmo Hotel occupied the present area of the current post office on Grand Street. The building was erected in 1887 and opened on May 7, 1887, across the street from the Erie station (now the Village of Goshen Police Station). Fire destroyed the hotel in February 1920.

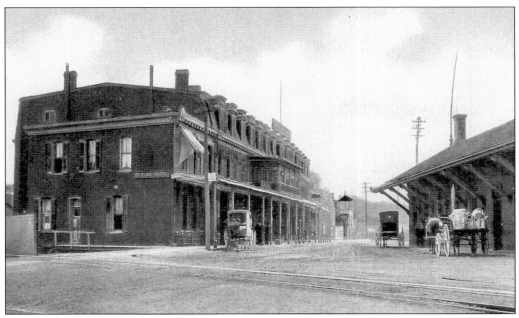

The St. Elmo Hotel was a well-appointed brick structure containing rooms with all conveniences and modern improvements. It was owned by Robert B. Hock, the village president, and it was managed by his son Fred B. Hock. The hotel was one of the most popular among the traveling men of any hotel along the Erie Railroad line.

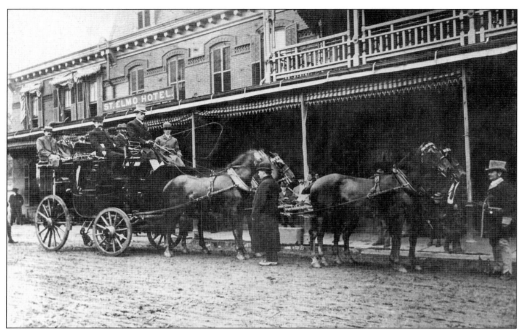

A stage coach is seen in front of the St. Elmo Hotel on Grand Street, the site of the current post office.

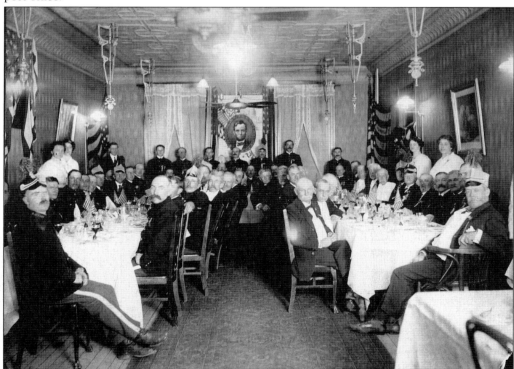

This interior photograph is of the dining room of the St. Elmo Hotel, taken on February 12, 1914, at the dinner for the Sons of Veterans of the Civil War.

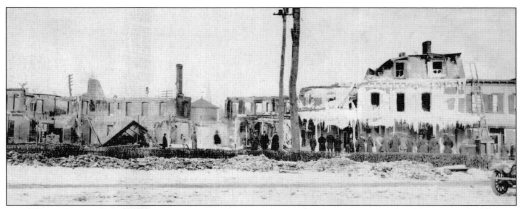

A cold night on February 1, 1920, saw the St. Elmo Hotel in flames. The blaze is believed to have been caused by an overheated chimney that ran up through the building between John N. Hansen's barbershop and the Grill restaurant run by James Tandine. The *Independent Republican* reported on February 3, 1920, that the fire was discovered by Anna Doulin, who was employed as a waitress at the Grill. Fire Chief Edward Farrell realized the local firemen would need assistance to cope with the fire and called Chester, Florida, and Middletown for help in fighting the fire in weather that was 10 degrees below zero.

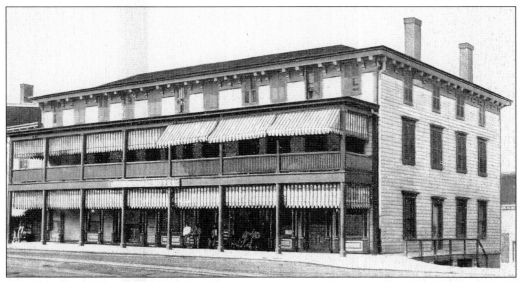

The Occidental Hotel was located on the vacant lot next to the post office. The Pavilion Hotel, as it was first known, was built by Gen. George D. Wickham in 1841 to coincide with the opening of the Erie Railroad from New York to Goshen. Later the hotel was operated by Gilbert Gale, and then by John S. Edsall (owner of Edsall's Hambletonian).

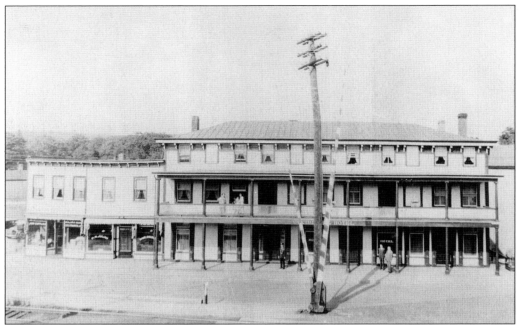

The hotel acquired the name Occidental when Col. E. R. Abbott took possession in 1872. In 1881, the proprietor was A. Brownson. In 1892, Thomas Bradley purchased the hotel in partnership with A. H. May. The hotel was owned by Dinero Monastra from 1966 to 1976. He was also a village trustee in the 1970s and early 1980s. The hotel retained the name Occidental until it was demolished in 1983 after a fire. Bill Lewis' Sporting Goods store and T. J. V. Cullen's Insurance Agency, and Triggin's barber shop occupied the stores in the left of the photograph.

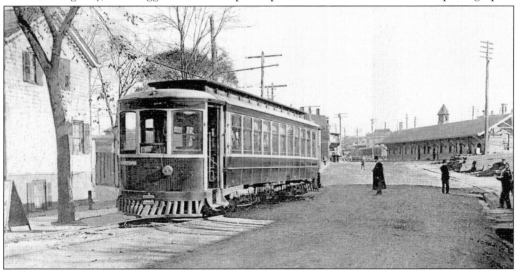

The photograph above is of the Middletown-Goshen trolley on Grand Street, which was operated by the Middletown-Goshen Traction Company. Construction of the line from Middletown began in 1894. Before the end of 1924, motorbuses supplanted the use of trolley cars. On October 21, 1924, due to the lack of repairs and money to make the repairs, the power plant at Mechanicstown broke down. Without electricity, the trolleys stopped running between Middletown and Goshen.

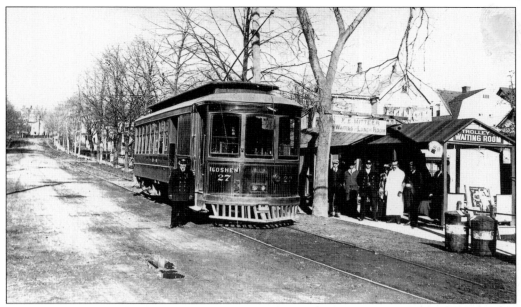

This is a view of the Middletown-Goshen trolley on Grand Street with the F. E. Mitteer waiting room.

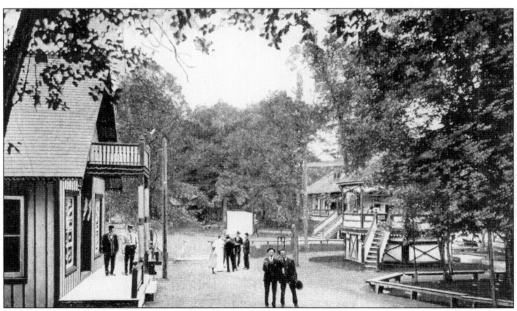

Opposite the Orange County Golf Club, Midway Park was an amusement park owned and operated by the trolley company. The park contained a roller coaster, dance hall, observation tower, and boat rides on the Wallkill River. The park opened August 25, 1894, and was active until 1924 when the trolley service discontinued.

James Dougherty, the author's great-grandfather, is seen on the left at the harness shop that was located on the corner of Greenwich Avenue and New Street. The two younger men in the photograph are posing with parasols that were probably found in one of the wagons. James Donovan operated a manufacturing and carriage painting plant located on this site beginning in 1889.

Not much has really changed looking east toward Harriman Square in this view of Greenwich Avenue. New Street is the immediate left in the picture. The Sunoco service station is on the site of the house to the right in the photograph.

Three

SCHOOLS

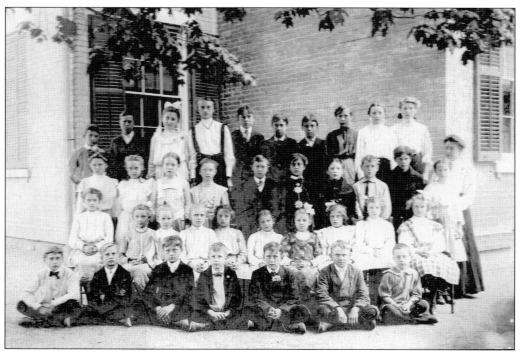

The Farmers Hall Academy, currently the site of the town hall, was erected about 1773. Noah Webster taught here for a short time in 1782 and wrote his spelling book during his stay. The photograph shows an elementary school class posing outside the building.

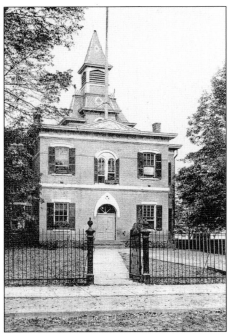

In 1822, the Farmers Hall Academy was organized as a common school within the village. The school district purchased the building in 1843. In 1876, an addition and bell tower were added. By 1885, two more rooms were constructed to the rear. In 1911, the Farmers Hall Academy was sold to the Town of Goshen. It has served as the town hall ever since. On December 12, 1992, a serious fire almost destroyed the building, but it was rebuilt and still serves the community as the town hall.

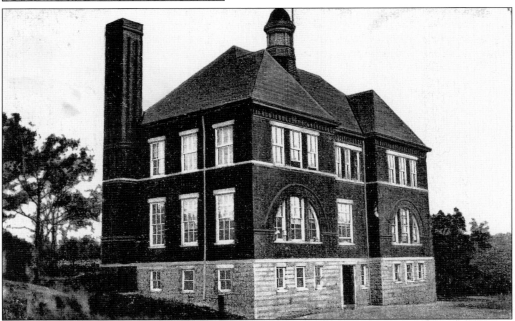

The first Goshen High School, built in 1890, was located on the corner of Webster Avenue and Erie Street near the hill to the rear of the Main Street School. The Webster Avenue building was torn down in 1961. The 1908 Goshen High School yearbook, *The Pioneer*, stated: "During the past year the school house had been more crowded than ever before. Classes are tucked away in the offices and at times two teachers are having classes at the same time in one room. Let's have a new high school or an enlarged one which we may be proud to show to the visitors of other towns."

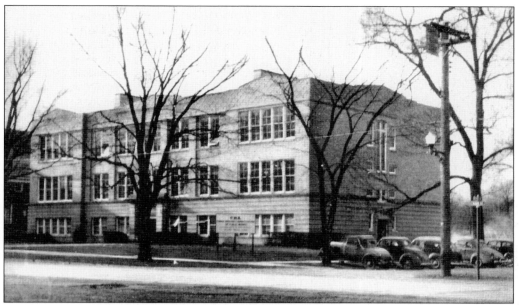

The "new" Goshen High School now housing the Goshen Central School business offices on Main Street was built in 1911–1912. The 1911 high school yearbook, *The Pioneer*, stated: "The new high school is fast nearly completion. Contractor W. C. Altman has about finished. The main entrance will be on Main Street with two entrances at the sides, one for the boys on Erie Street and one for the girls on the side next to the Music Hall. It is doubtful if any town in this part of the state has a more complete and up-to-date school than Goshen will have when this magnificent building is completed."

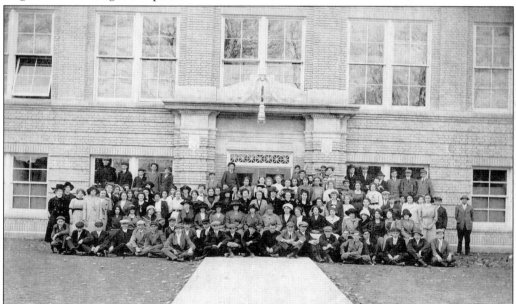

This photograph shows the entire student body of the newly completed Goshen High School (Main Street School, currently used as the school district's business offices) when it opened in 1912.

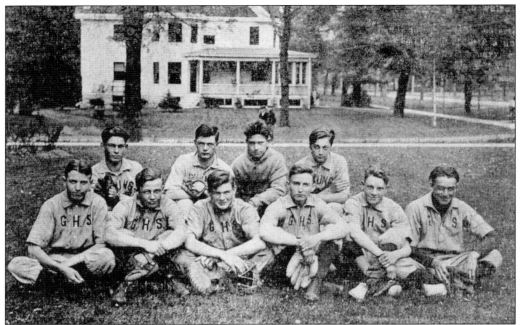

Seen here is the Goshen High School baseball team being photographed on the front lawn of the Main Street building in 1916.

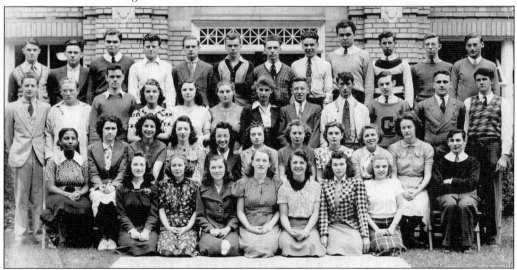

The class of 1939 poses in front of the Goshen High School on Main Street. The students are, from left to right, (first row) Alice Walsh, Shirley Burnett, Rose Filipowski, Marjorie Baldwin, Helen Loyas, Sylvia Markowitz, and Jean Johnson; (second row) Marjorie VanDyke, Rits Hingerty, Anna Hegele, Helen McGowan, Margaret Bonauto, Marjorie Carrey, Regina Weiss, Marion Smith, June Holcombe, Helen Prosser, and David Markowitz; (third row) Raymond Schwarz, Walter Moran, Frank Littner, Jennie Zielenski, Virginia Vavaricka, Etta Fowler, Loretta Sunstrom, Frank Bonauto, Edward Checke, Cuthbert Gillespie, Alton Schmick, and Robert Milborn; (fourth row) Thomas Lane, Vernon Keyes, Theodore Wahl, John Connor, David Pardy, Charles McNeice, John Murphy, James McNeice, Clarke Wahl, Norman Bailey, Robert Farnum, and Henry Helhoski.

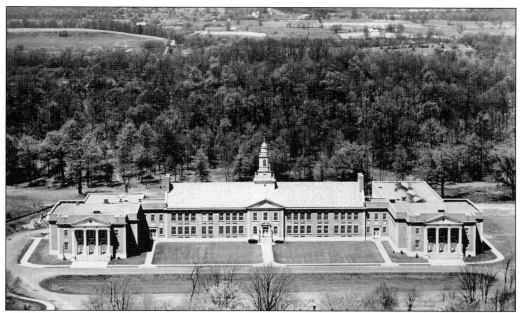

An aerial view of the Charles J. Hooker building located at Lincoln Avenue and Erie Street. The school was completed in 1939 to house an ever-growing school population and remains to this day one of the most beautiful school buildings still serving the district as the Middle School. The building was built at a cost of $726,341.35 and was dedicated September 26, 1940.

In 1904, Catherine Garr, a long time resident of Goshen, gave $8,000 for a new Catholic high school. The cornerstone of Garr Institute, which succeeded St. John's Academy School, was laid Sunday afternoon December 13, 1904. The Garr Institute was in the building located on the corner of Murray Avenue and Erie Street. St. John's Academy School was in the building next to St. John the Evangelist Church, which was then used mainly as a convent. F. A. DeMeuron of Yonkers was the architect of Garr Institute.

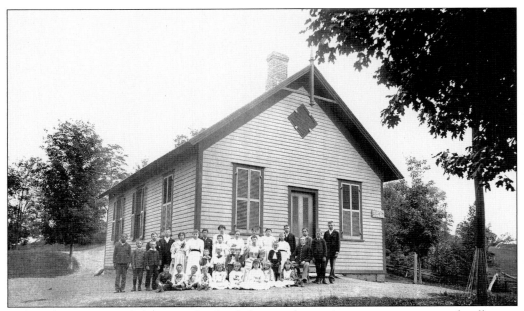

Before the creation of the central school district there were many one-room schoolhouses throughout the town. This was the Gates schoolhouse in 1895 that was located on Gates School House Road.

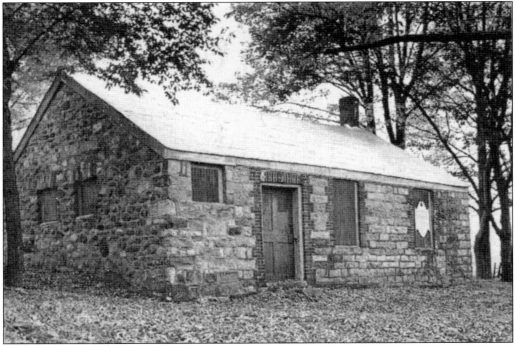

The old stone schoolhouse that sits along the Goshen-Florida Road (Route 17A) is owned by the Minisink chapter of the Daughters of the American Revolution. The land for the school was donated by Charles Howell. On December 6, 1938, the taxpayers voted to discontinue the school's use and become part of the Goshen Central School system.

Four

FIRE COMPANIES AND PARADES

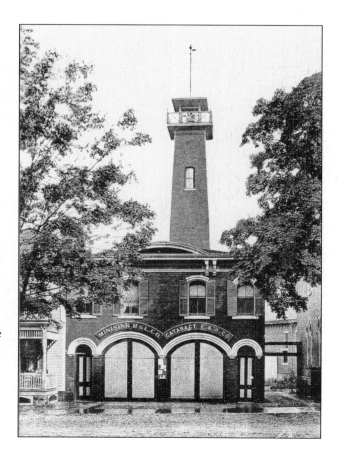

The Main Street firehouse was built in 1871, replacing an earlier wood frame firehouse on the same site. The building housed both the Minisink Hook and Ladder Company and the Cataract Engine and Hose Company until recently, when both companies moved to their own new firehouses. The bell tower was constructed in 1879 to house the bell manufactured by the Clinton H. Meveely Bell Company of Troy, New York. The 1889 fire bell served its purpose of routing firemen until the use of an electric siren. The bell was moved in 2006 to the new Cataract firehouse on Green Street.

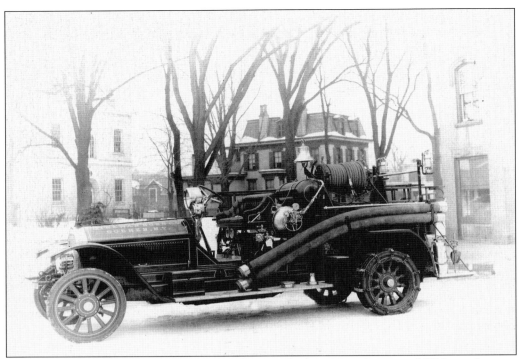

The first motorized Dikeman fire truck is photographed on Main Street and Webster Avenue. The town hall can be seen to the left.

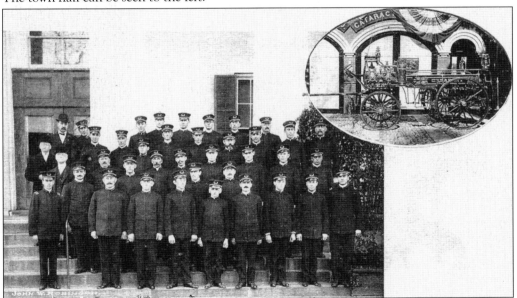

In 1841, Goshen suffered its first big fire. In 1843 a second fire occurred destroying buildings along Lawyers' Row including the town clerk's office and all the village's records. On August 29, 1843, the Goshen Fire Engine Company No. 1 was organized. This company became the Cataract Engine and Hose Company and was the only fire company until 1871 when the Rescue Hook and Ladder Company was formed, that later became the Minisink Hook and Ladder Company.

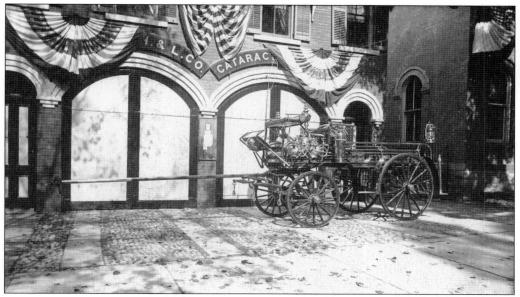

A horse-drawn fire truck is displayed in front of the Minisink Hook and Ladder Company and Cataract Engine and Hose Company firehouse on Main Street.

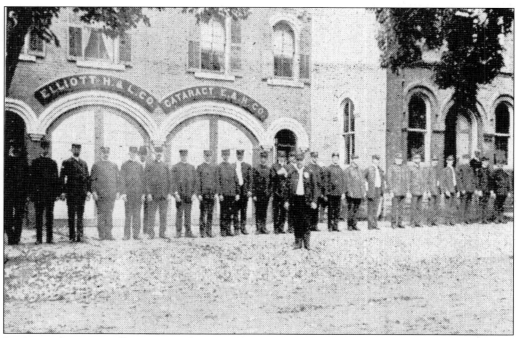

In this early picture, firemen are photographed in front of the Main Street firehouse when the Cataract Engine and Hose Company shared the firehouse with the Elliott Hook and Ladder Company. The Elliott Hook and Ladder Company disbanded when the Minisink Hook and Ladder Company was formed in 1906. The Dikeman Hose Company was organized in 1873.

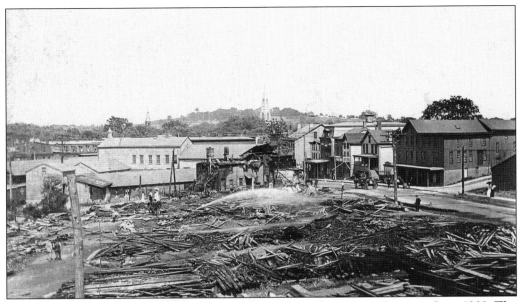

Seen here are the ruins of the Sayer Lumber Yard fire on West Main Street in June 1909. The fire also destroyed the Olivet Chapel across the street that was rebuilt and still stands today. The building on the right in the background was used as a storage building for the furniture store and funeral business of W. D. Van Vliet and Son. The building was recently demolished because of its poor condition. The Van Vliet main store was in a building commonly known as the country store flatiron building on Harriman Square. That building was razed to make way for the current flatiron building occupying the site.

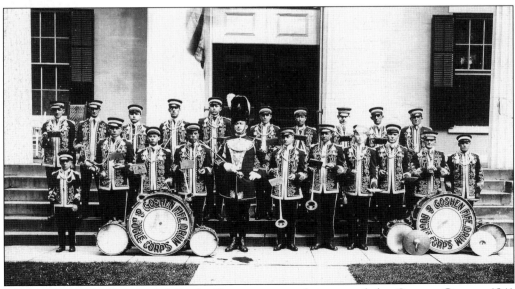

The Goshen Fife, Drum, and Bugle Corps pose on the steps of the Orange County 1841 Court House.

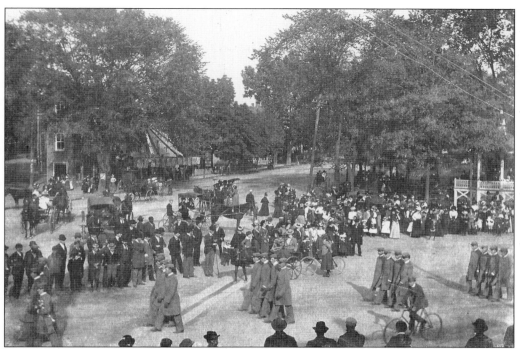

A very early fire parade crosses Park Square. The photograph was taken before the installation of the Harriman Memorial Fountain in 1911. No motor vehicles appear in the picture.

A military unit marches down Main Street past the Van Vliet store sometime around 1920. Note the photographer on the roof of the Van Vliet store walkway cover. This photograph is a rare glimpse of the house that was between the store building and Wilcox Garage further down Main Street.

This photograph shows the parade for the dedication of the Orange Blossoms Monument that is located on Main Street and Park Place. The monument was dedicated September 5, 1907. The photograph was taken on West Main Street in front of where Howell's Café is located today.

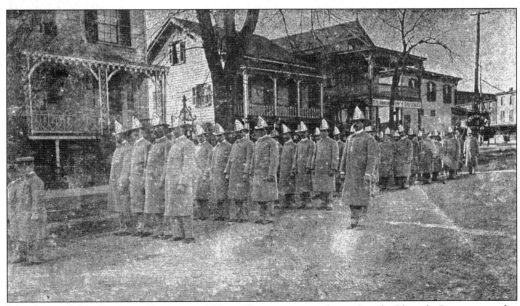

Members of the Cataract Engine and Hose Company march up South Church Street past the site of the current bank building on the square.

Five

CHURCHES

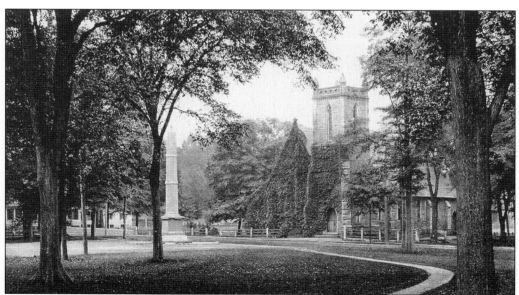

Saint James' Episcopal Church was incorporated on June 25, 1803. The first white frame building on the present site was completed in 1804. The land for the church, as well as the land for the church cemetery on South Street, was donated by Dr. John Gale. In 1851, the vestry resolved to build a new church to represent the architectural tastes of the day. The present stone church was completed in 1853.

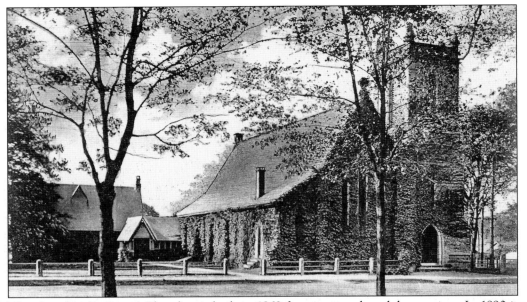

The chapel at St. James' Church was built in 1869 for winter and weekday services. In 1890 it was deconsecrated as a chapel. For many years, it served as the parish hall until a new addition was added in 1961. On December 27, 2002, a fire broke out in the 1869 chapel. The Goshen Fire Department responded and saved the rest of the church. The chapel has been restored and once again serves as a chapel as in 1869.

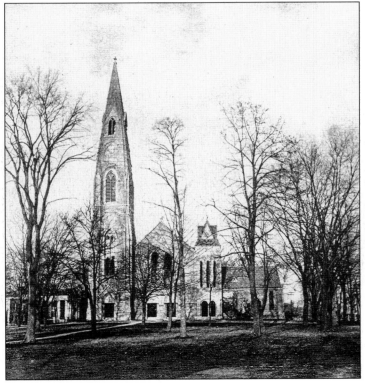

The First Presbyterian Church was organized in 1720 and a building was erected. In 1810, a new wooden church was constructed. The present stone church was dedicated November 22, 1871. The church was built from plans by Daniel T. Atwood using blue limestone from the quarry near Florida. The steeple is 186 feet tall. In 1933, the village installed the clock in the steeple that at one time struck on every hour.

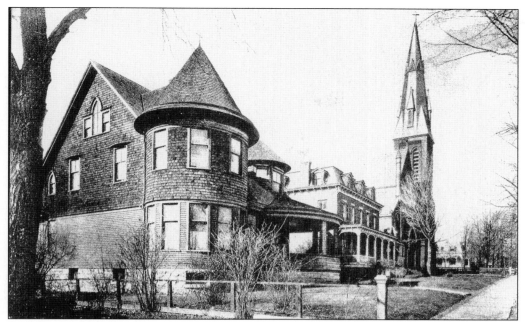

St. John the Evangelist Church on Murray Avenue was built in 1885. Col. Arthur Crock was the architect. The photograph shows the rectory, which was built in 1899 and replaced by the current rectory when fire destroyed the original building. The middle building served as Saint John's Academy School and as the convent for many years.

The first Catholic church was located on St. John Street in 1847, where the current parking lot is for the town hall. That structure served the congregation until the present church on Murray Avenue was completed. The building then became the Central Theatre run by the Hock family. Later it became the Town of Goshen highway department garage until it was demolished on July 10, 1967.

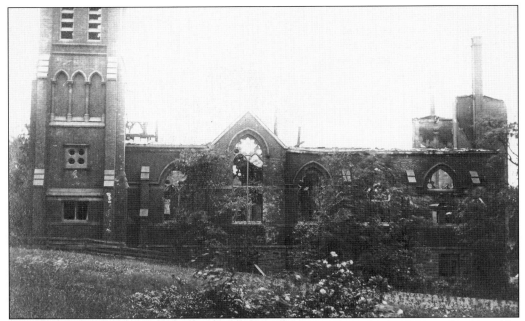

St. John the Evangelist Church was destroyed by fire on June 5, 1918. The fire was discovered by the sisters living next door to the church. Fire Chief Hock called for extra help from Middletown but the church was totally destroyed with the exception of the steeple.

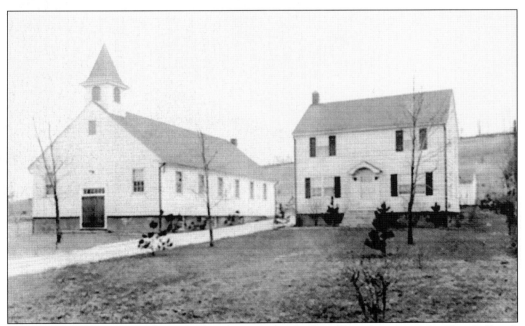

The Goshen Christian Reformed Church, just outside the village limits on the Florida Road, Route 17A, was established in 1934. The church in the photograph served the congregation from 1939 to 1952, until the present larger brick church was built near by. The parsonage was also built in 1939.

The current Goshen United Methodist Church was dedicated in 1884. The church site was the location of the Gale-Wescott house.

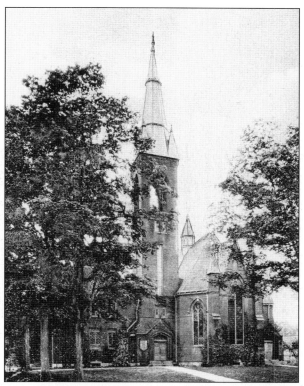

The first Methodist Episcopal Church was dedicated August 30, 1848, in this building that was on the corner of Canal and North Church Streets. The site was purchased from Bridget Wickham, the widow of George D. Wickham, on November 22, 1847. The church paid $100 for the 90-by-100-foot lot. Construction of the church cost $2,769. The building was removed recently to make way for the current bank building. The building served for years as part of the Conklin and Cummins Lumber Yard.

St. John's African United Methodist Protestant Church was dedicated November 3, 1878. The frame building was built on West Main Street, where it remained until the 1960s, when expansion of McBride Trucking acquired the site. The building on the right served as the church hall.

This church building was constructed in 1909 and known as Olivet Chapel. The original 1903 building was destroyed by the Sayer Lumber Yard fire across the street. The building is presently St. John's African United Methodist Protestant Church.

Six

HARNESS RACING

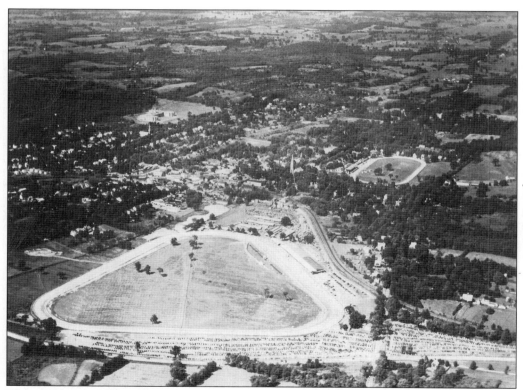

This aerial view of the village shows the mile track, Good Time Park, in the foreground, home of the running of the Hambletonian. Historic Track, a half-mile oval, is seen in the background. With the two harness tracks, Goshen was the smallest community in the world with two tracks devoted exclusively to harness racing.

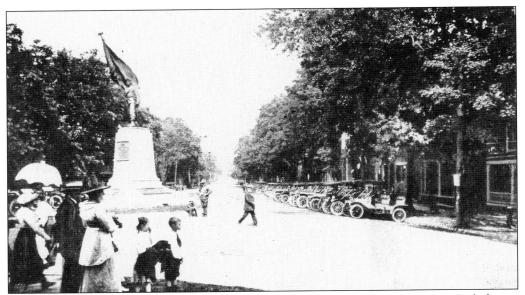

In the early 1900s, people on Main Street were on their way to the Goshen Driving Park during race week.

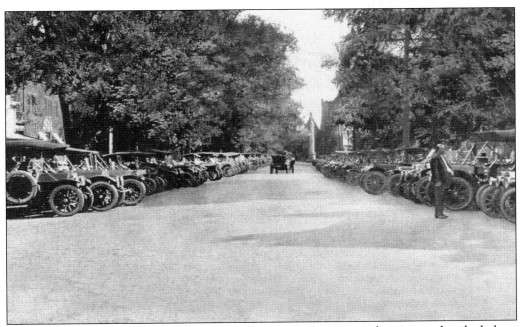

With the advent of the automobile, people drove to Goshen to see the races and parked along Park Place. The Wisner Monument is seen in the distance.

This view of the entrance to the Goshen Driving Park on Park Place later became known as the Orange County Driving Park, and then Historic Track when the Harriman family purchased the track. In 1892, Kate Sharts moved into the building at the entrance to Historic Track. As the official hostess of the track, she managed the Japanese teahouse on the infield. Her house was a popular meeting place for the racing community until her death in 1939.

Historic Track was designated in 1966 as a historic landmark by the National Park Service. It was the first time a designation was made for a site devoted exclusively to sport.

This is an aerial view of
Historic Track.

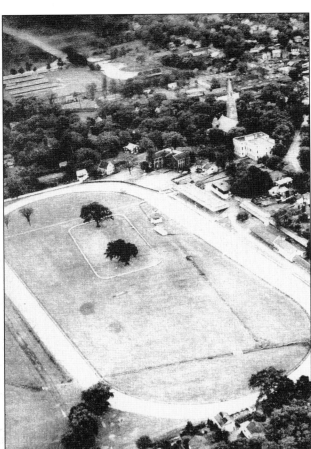

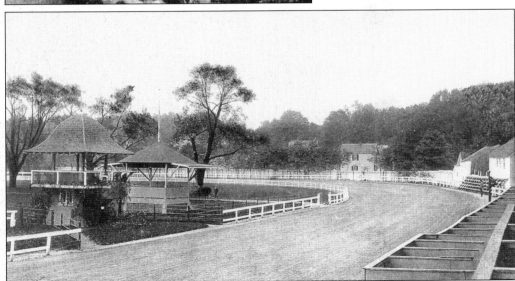

This image shows the home stretch of Historic Track with one of the original bandstands and
one of the new bandstands.

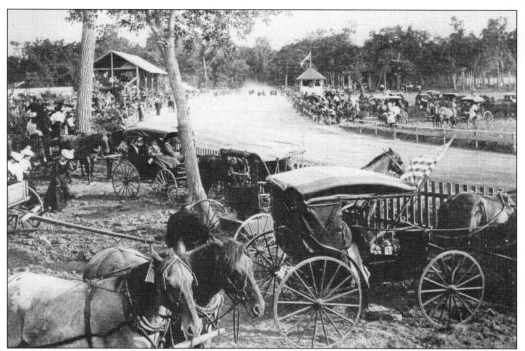

The photograph, taken July 4, 1859, shows the home stretch of Historic Track. The original grandstand is to the left. The horses and buggies in the front are standing in the area of the current parking lot of the Goshen Inn. The photograph is thought to be the oldest known photograph of Historic Track.

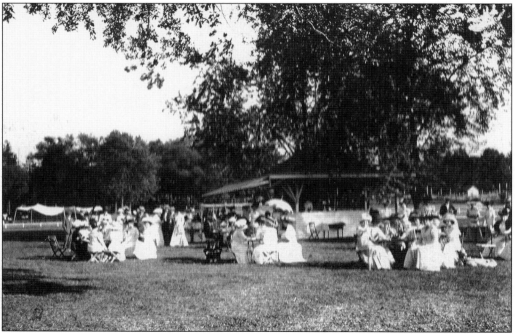

A *c.* 1900 tea party is seen taking place on the infield of Historic Track.

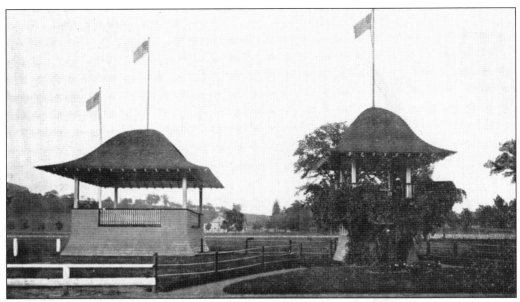

The new bandstands of Historic Track are depicted in this image after the 1911 renovations.

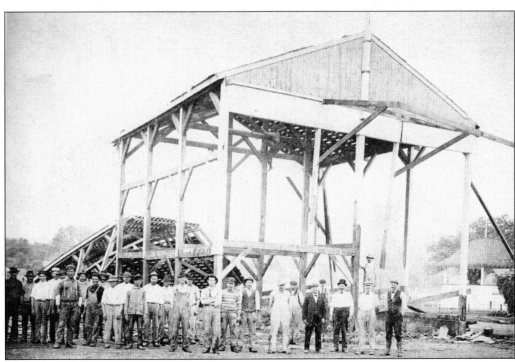

Workmen pose in front of the remains of the original grandstand as it is being demolished in 1911 at Historic Track.

J. Howard Ford was an owner of a standard bred horse farm outside of Goshen. He built the stables for his horses in 1912. After Ford's death, the building remained empty until the 1920s, when William Cane bought the building and named it the Good Time Stable. In 1951, it became the Hall of Fame of the Trotter and is now known as the Harness Racing Museum.

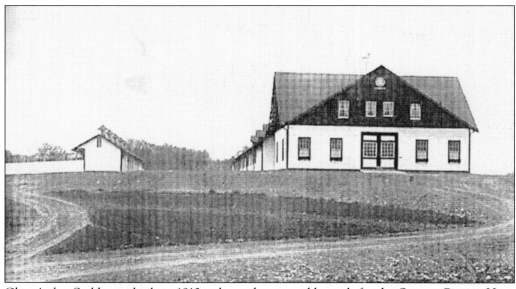

Glen Arden Stable was built in 1913 to house horses and kennels for the Orange County Hunt Club. Issac W. Mandigo was the architect. The site today is Arden Hill Hospital, also known as the Orange Regional Medical Center.

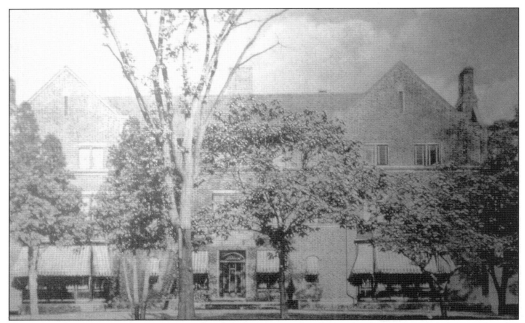

The Goshen Inn was built in 1912 by the Harriman family and others as a club house for the Orange County Hunt Club. A fire in 1929 caused the building to remain vacant until 1941, when Carl and Walter Neithold purchased it and restored the building.

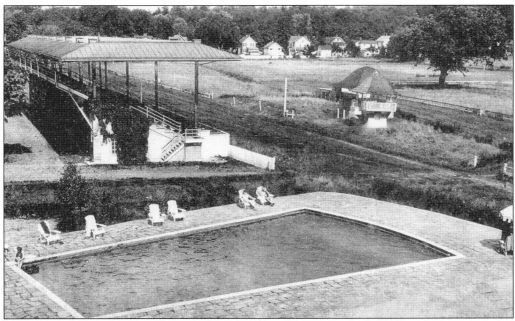

The Goshen Inn pool, built in the 1940s, was adjacent to Historic Track. The area is currently a parking lot.

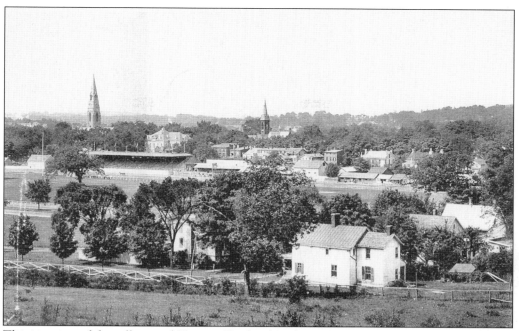

This is a view of the village and Historic Track taken from upper Orange Avenue.

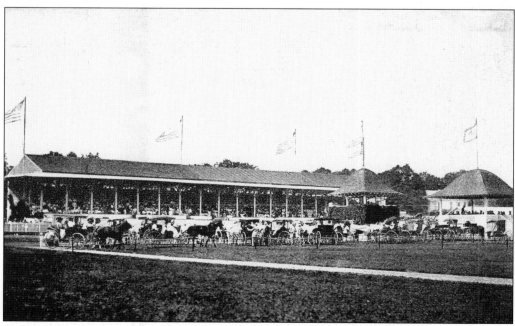

Horses and carriages occupy the infield of Historic Track in this image taken after 1911.

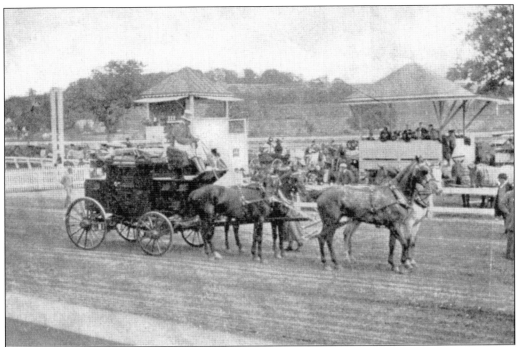

Historic Track was the site of a horse show in 1904. The original bandstands are seen in the background, as well as Slate Hill when it was fields, before the construction of any houses.

Shown in this photograph is an Orange County Horse Show at Historic Track.

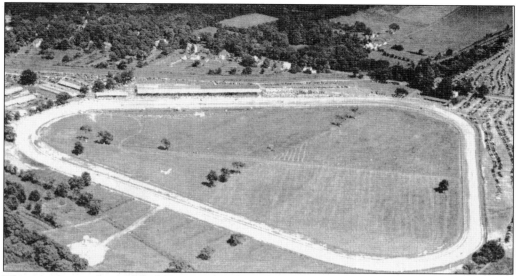

This aerial view shows Good Time Park, where the Hambletonian was run from 1930 to 1956. Joseph S. Coates built the track in 1899. Coates developed the track as a training course for trotters on a mile track. In 1926, William H. Cane purchased the track from the Harriman family. It was Cane who made the site an active race track. The site, near Green Street and South Street, is now proposed to be a condominium development.

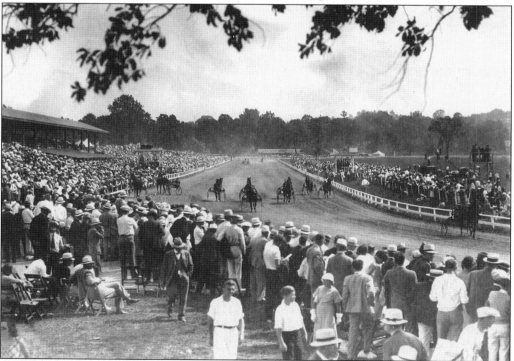

Annually on Hambletonian Day, as seen in this photograph, horse lovers thronged through the gates of Good Time Park to witness the racing of America's finest and fastest three-year-old trotters in competition for the Hambletonian Stakes, the Kentucky Derby of trotting.

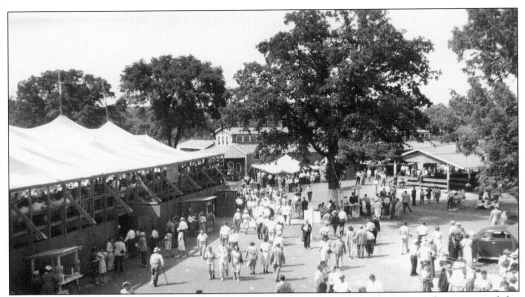

The stable area of Good Time Park was demolished in the 1960s. The tree in the center of the photograph still stands.

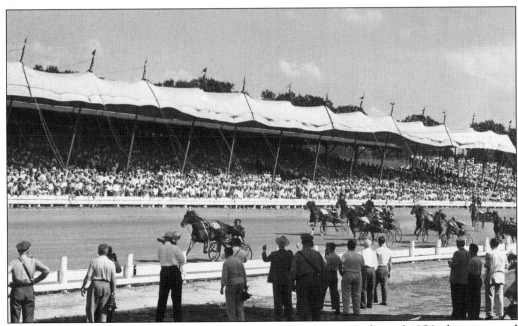

The Hambletonian Stakes was run each summer at Good Time Park until 1956 when it moved to Duquoin, Illinois. It is now run at the Meadowlands race track in New Jersey.

Seven

HOMES AND STREET SCENES

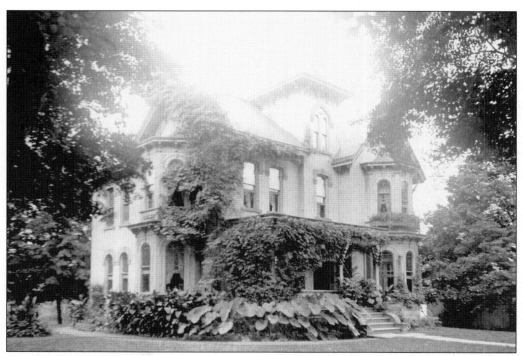

This excellent example of Victorian architecture on South Church Street, across the street from the park, is the Makuen house. The house was built in 1876 by Floyd and Christine Cowdry Reeves. The builder was David Roe. The Reeves family owned a store on West Main Street in a building that is no longer standing. It was on the site of the parking lot that is now serving the Kennett Gymnastics School. The descendants of the Reeves, the Makuen family, still reside in the home.

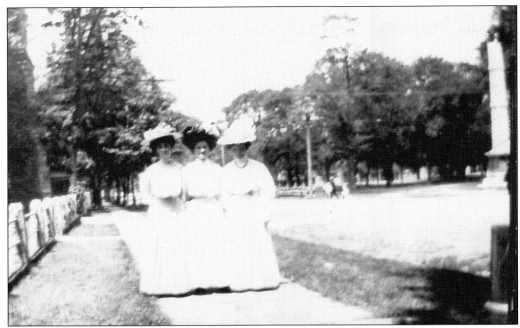

Mary Dougherty (right), the author's great aunt, and her friends stroll along South Church Street about 1900 in the area of St. James' Church.

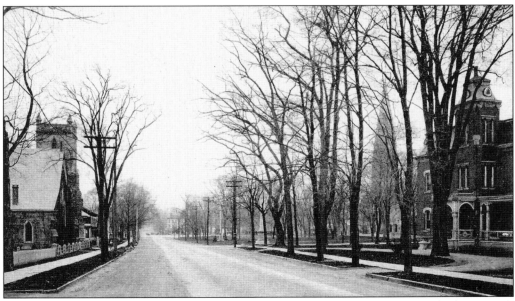

A view of South Church Street looking toward Harriman Square shows St. James' Church on the left and the Post/Thompson house on the right. The house was purchased by the First Presbyterian Church. It was razed in the 1960s, and the site remains vacant.

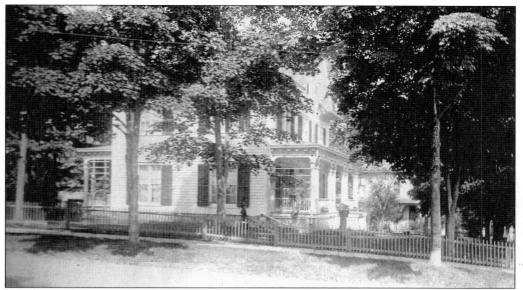

On the corner of South Church Street and South Street sits the early Victorian home belonging to generations of the Wallace family. The house was built in 1853 by Aaron Van Duzer, for his daughter Hannah when she married Harvey Wallace. The wood for the construction of the house came from trees on the Van Duzer farm on Route 17A, the road to Florida.

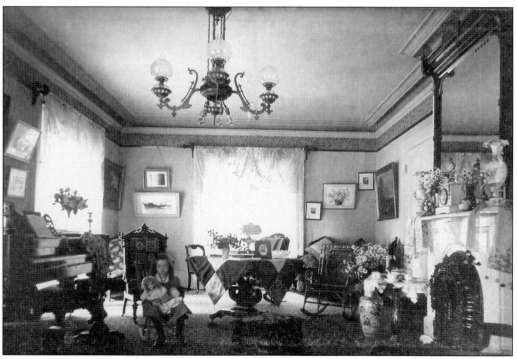

Photographed in the Victorian living room of the Wallace House around 1900 is Sarah Howell Lockwood, holding a doll. Her mother was Grace Wallace Lockwood. The Lockwoods lived in a house further up South Street.

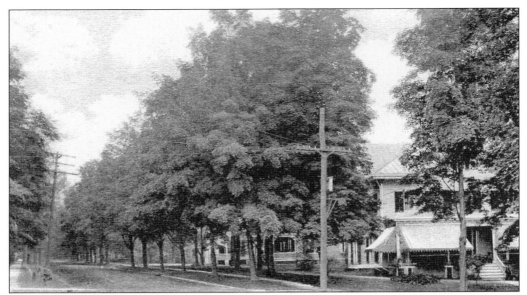

This is a view of South Street and the Wallace house on the right. Before the construction of the Goshen Inn by Harriman family members and others for the Orange County Hunt Club, the club rented the Wallace house for some time. It was known as Glenmere Lodge at this time.

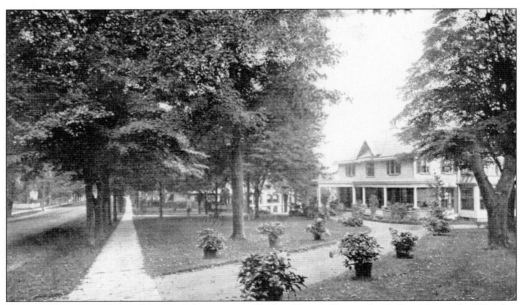

Calvert Vaux was the architect of this unique Gothic Revival home built for Alexander Wright, founder of the Goshen National Bank. Built in 1853, the house was built in an H form with steeply pitched gables and chimney pots. It features a 25-foot-tall glass-domed conservatory. The house sits on the corner of South Church Street and Parkway and overlooks Historic Track. In recent years, the house has been restored to its original grand condition.

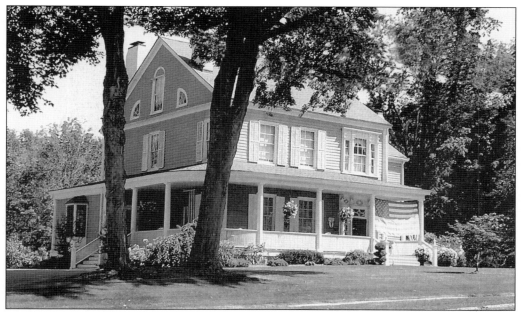

In 1802, John Hurtin built this home on the corner of South Street and South Church Street with money he had won in an early American lottery. In 1826, Issac Van Duzer, a lawyer from Cornwall, purchased the house. From that time until 2003, his descendants, the Gott family, lived in the house. The house has been meticulously restored in the past few years by its current owners.

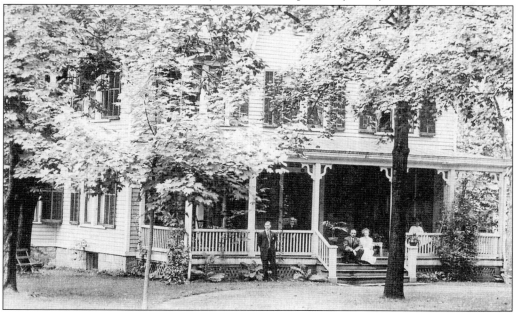

This fine Victorian home along tree-lined South Street was the home of Dr. E. G. Parker, a dentist who came to Goshen in 1885. The local newspaper, *The Goshen Democrat*, reported in 1904, "Dr. Parker's parlors are fitted up in magnificent style and the equipment of his laboratory and operating rooms are thoroughly modern. Dr. Parker is public spirited and willing to lend his support to all commendable projects for the interest of Goshen."

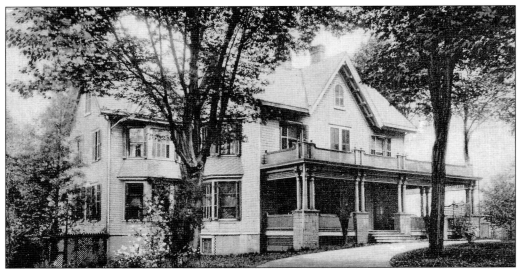

The John Covert house, Tres Pines, was built in the 1890s. From about 1920 into the 1960s, the house was owned by Joseph Donovan. Donovan was born in Goshen in 1892 and served as fire chief from 1929 to 1940. The house is a fine example of Victorian architecture in the village's historic district.

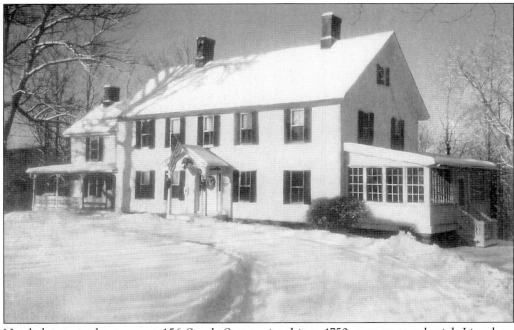

Nestled among the trees, at 156 South Street, sits this c. 1750, two-story colonial. Listed on the National Register of Historic Places, this house was originally built by the Everett family, who was among Goshen's earliest settlers. The Everett-Bradner House was home and court (law office) of Orange County surrogate James Everett who held that office from 1779 to 1815. This residence for generations housed the Everett and the Bradner families. In 1924, Frank M. Gibson purchased the house, where his descendants currently reside.

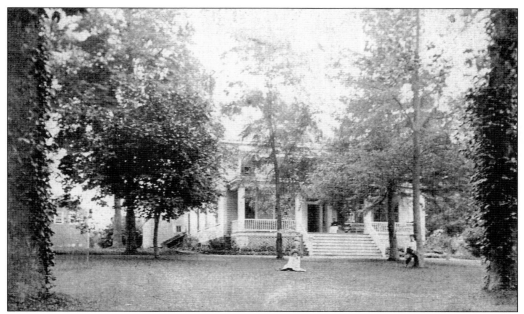

Located on South Street the Wisner House was inherited by racetrack designer Joseph S. Coates from his revolutionary ancestors. Coates called the homestead Oak Hill. The original structure was built about 1740. The front portion of the house was constructed about 1830 by Henry G. Wisner. A final wing was added in 1905. This was the residence of Gabriel Wisner, who was killed at the Battle of Minisink.

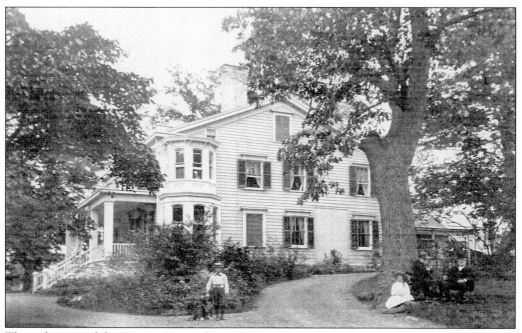

This side view of the Wisner House shows George Wisner seated on the far right. The house is today the home of the Andrews family, Wisner family descendants.

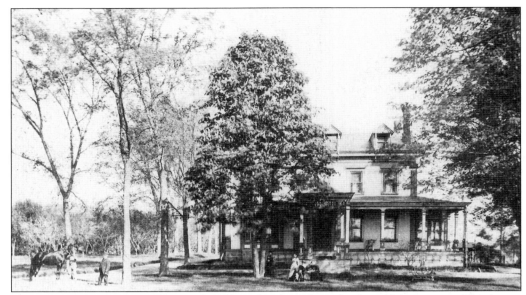

Elm Lawn was constructed around 1850 and enlarged in the late 19th century. The house became the office and living quarters of the Leprestre Miller Stock Farm in 1916. Still standing today, the house is at the entrance to the Paddock condominiums on South Street.

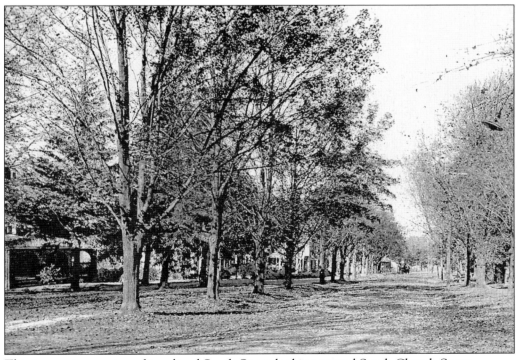

This is an autumn view of tree-lined South Street looking toward South Church Street.

Houses along South Church Street are seen in an area recently added to the village's historic district.

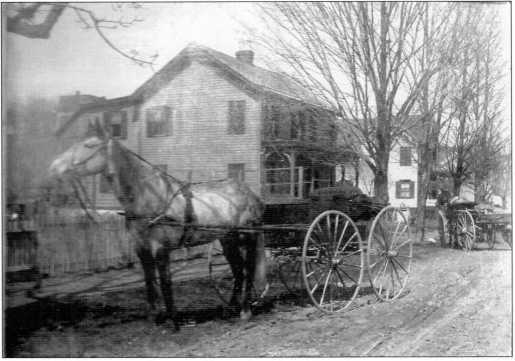

This unique photograph of horses and buggies on Middle Street is a view of how streets looked before the advent of the automobile.

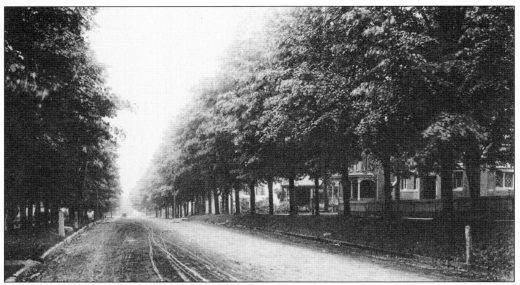

This is a view of tree-lined Murray Avenue when it was still a dirt street.

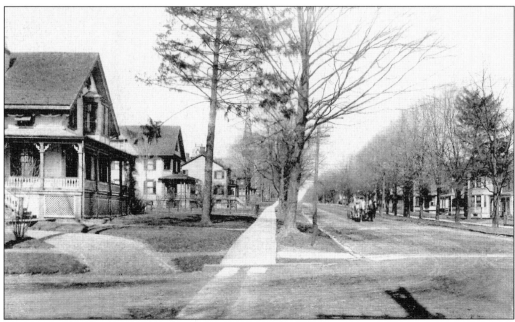

Not much has changed today from when this scene of Murray Avenue was taken from North Church Street.

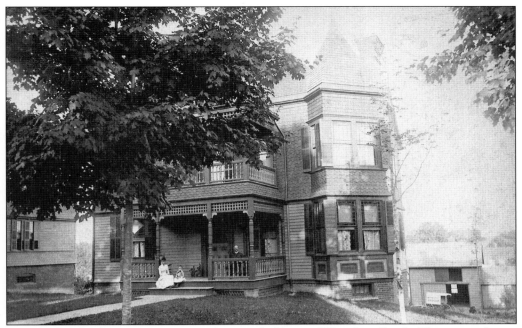

In 1903, shortly after its construction, this was the home of Theodore Smith. This unique house on Murray Avenue is an example of the large Victorian homes that were built along Murray Avenue starting after 1880. In the 1960s, it was the home of the Parks family.

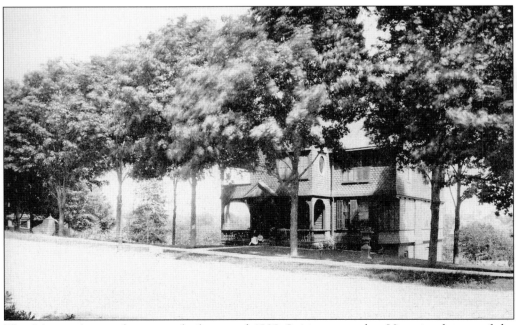

This Murray Avenue home was built around 1900. It is among other Victorian homes of the same period. In the early 1900s, it was owned by the Hatfield family.

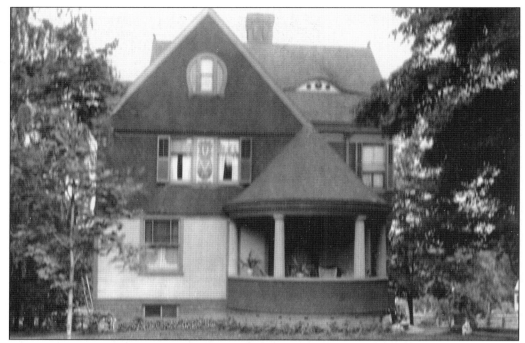

Built on Murray Avenue in 1889, this fine example of Victorian architecture still contains many original features including original woodwork, stained glass windows, and horseshoe shaped trim around the attic windows. The property was originally owned by Edwin Dikeman, a local druggist, who sold it to Robert Weir in 1883, who probably built the house. The Dikeman Hose Fire Company is named in honor of Edwin Dikeman, who was a village trustee and president of the village.

This is a side view of the Weir/Kirchner house. The house construction date of 1889 appears in the peak of the house. Until recently, the house was owned by the Margaret Kirchner Dillon family.

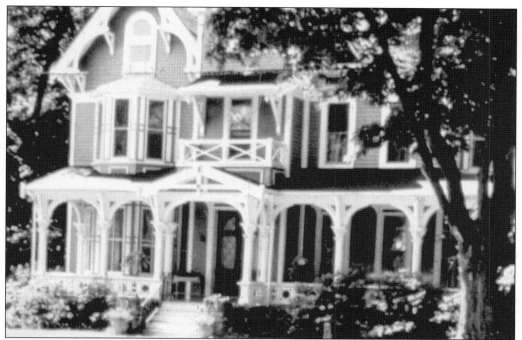

This is a view at the corner of Murray Avenue and North Church Street. For many years, this was the residence of Noreen Church, who returned it to its grand Victorian condition.

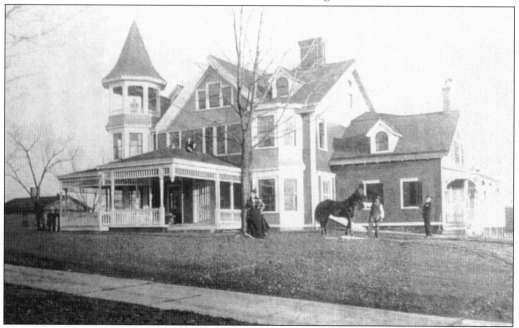

John Bradner resided here in the late 1800s. The house was once of a simpler style but Victorian architectural elements were later added. When D. C. Durland owned the house in the early 1900s, he called it Tower Terrace. In the 1960s, it was owned by the Sutherland family, who operated a garage on the site of the bank building on the square.

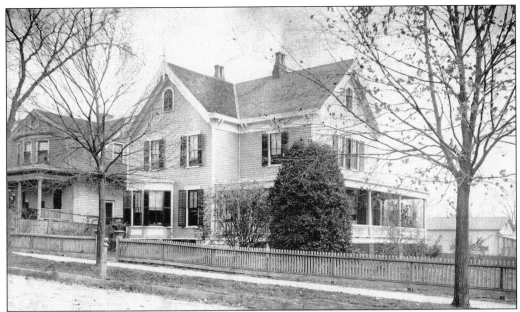

This Victorian house on the corner of Murray Avenue and Grand Street was the home of Mary "Mae" Bassett and her sister Jennie for many years. Mae ran a pharmacy on Main Street. In the early 1900s, it was the home of J. B. Dusenbury. Recently the house has been completely restored.

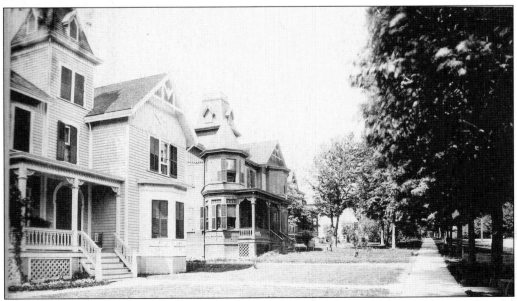

This view of Murray Avenue looking up from North Church Street towards St. John the Evangelist Church shows three similar Victorian homes that remain there today.

This is an early photograph of Maplewood, the current village hall. Ambrose S. Murray was a clerk, cashier, and president of the Bank of Orange County from 1834 until his death in 1885. The bank started in this building along Main Street. It later moved to the bank building on West Main Street in 1852. Murray was elected to the 34th and 35th United States Congress. He was married to Frances Wisner, the daughter of Henry G. Wisner, in 1836.

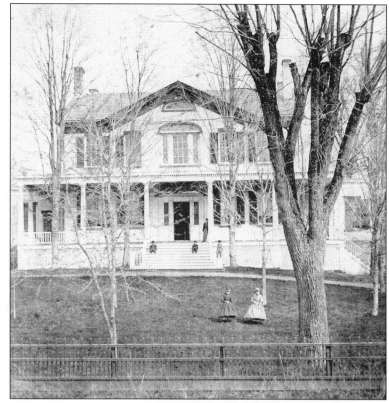

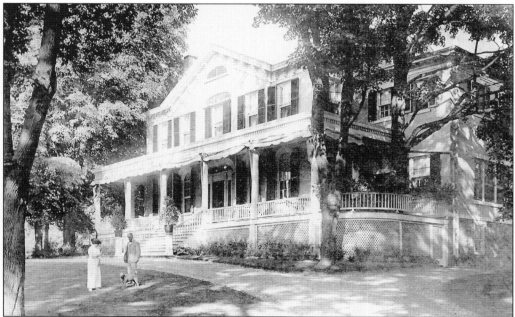

The Murrays are seen on the lawn of Maplewood. The home is directly across the street from the county government center that was once the site of the Interpines.

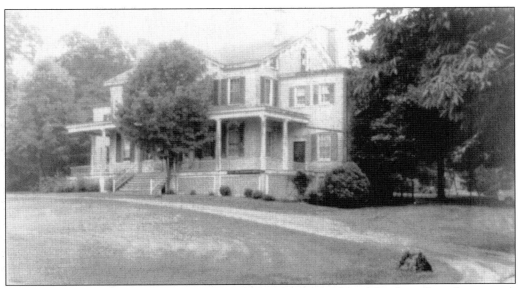

This is a view of Maplewood in the 1970s, before being purchased by the village for use as a village hall. Mayor Robert Rysinger was mayor when the village purchased the house. Before this time, the village government shared space in the town hall on Webster Avenue.

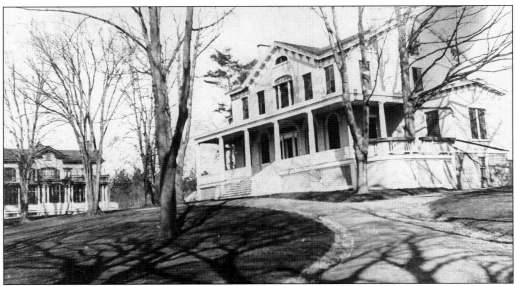

Along Main Street, Maplewood and the Pines are seen in the above photograph. The Pines was the site of "Birdseye" Yarrington's tavern, one of the village's first taverns. The house was later expanded by William Wickham in the 1860s. It later became the residence of Congressman Henry Bacon. A fire in 1919 destroyed the house, and it was replaced by the current Georgian brick structure where the Lippincott family resided for years.

Situated back from Main Street, near the village hall, Maplewood, is the Anthony Dobbins's Stage Coach Inn. In 1791 Anthony Dobbins bought the property and 10 acres on Main Street from Samuel Gale. By 1801, he had opened an inn. The inn was a favorite stop on the stagecoach line to Newburgh. John J. Heard inherited the home from his aunt who was Anthony Dobbins's widow. The house was the home of the Wilder family and has been the residence of the Hickock family for years.

In 1790, this structure was the residence and place of business of Coe Gale, a trustee of the Farmers Hall Academy (now the town hall). In 1796, the home changed hands from John Gale Jr. to John Johnson. It was at this time that the Masons were formed and met upstairs. George Grier lived here until his new house on South Street was completed in 1850. In the 1960s and 1970s, the house was the site of the Clothes Horse dress shop.

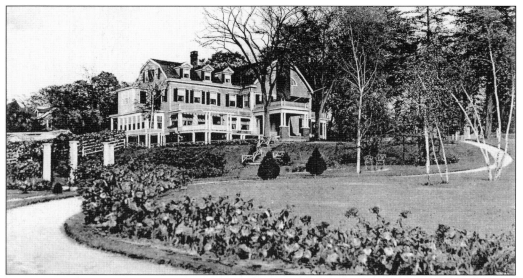

The Birches on Main Street, across the street from the Salesian property, was the home of the Alloway family. The photograph shows the side and rear portion of the house. Polly Alloway was an avid gardener and took pride in her flower gardens. For years, she hosted an antiques fair at St. James' Church during race week.

Gen. James Wilkin lived in this house located on Main Street across from the Salesian property. A member of the continental army, General Wilkin was a lawyer and member of the assembly. He was instrumental in 1812 in gaining recognition for the repair and maintenance of West Point. The house today has 19th century modifications such as the dormers, a bay window, and a large addition to the side. The house remained in the Wilkin family until the 1940s, when William Lunney resided here.

This early house is known as the Carpenter-Johnson House. In 1714, Solomon Carpenter settled in Goshen on Main Street and Sarah Wells Trail, which became known as Carpenter's Corners and then Johnson's Corners. The house was built about 1724 and was remodeled by James Carpenter before the Revolutionary War. Jeromus Johnson married Mary Carpenter in 1802, thus the name of the intersection as Johnson's Corners. The house was purchased by Gates McGarrah in the early 1900s.

James Denton had a tavern as early as 1796 in what was known as the Josey Sayer house by 1881. On March 4, 1801, the inauguration of the first Democratic president Thomas Jefferson was celebrated. The celebration had obtained a genuine success when, late in the day, the crowd in the bar room became so large the flooring gave way, and the entire crowd ended up in the cellar. The house was one of the earliest inns in the village.

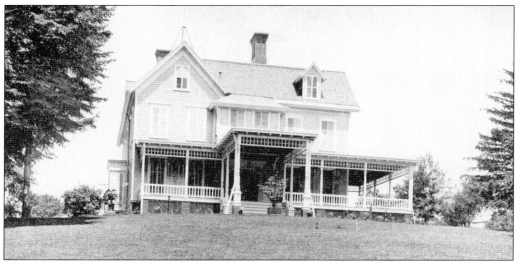

This house on Golden Hill Avenue was built about 1850 by the Murray family. It was owned by B. Van Steenbergh who was the first president of the foundry on Spring Street. The house then passed to Jay H. Newbury, who was also associated with the foundry. He called his residence Iosco. The large porch and dormer has been removed and the house was restored in recent years.

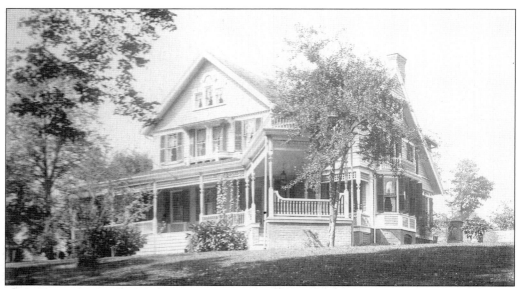

John T. Jansen purchased the property in 1843 and proceeded to build this house that was once in the Greek Revival style. It was later renovated with Victorian elements. Jansen, in his will of 1844, instructed his executors to complete the house after his death. The house was in the Shelton family in the late 1800s and then was purchased by A. V. D. Wallace in the early 1900s. The village park, now known as Wallace Park or Triangle Park, was associated with this property.

This house at the corner of North Church Street and West Street was built in the 1870s by N. C. Sanford, who owned the lumberyard across the street. Dr. Stanley and Alison Quackenbush lived here during the 1950s into the 1960s. A portion of the house now is a dentist's office.

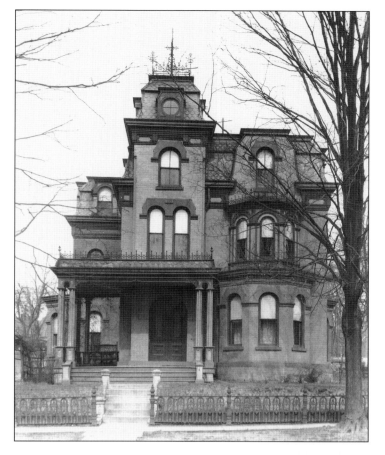

This is a view of Webster Avenue when it was considered the eastern side of Greenwich Avenue.

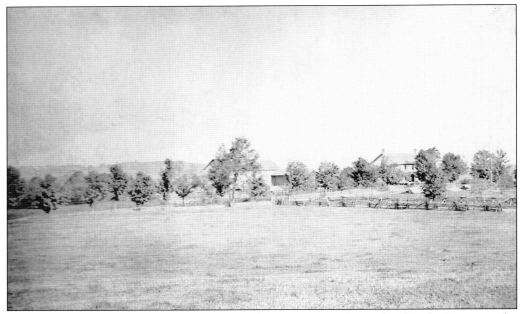

On the National Register of Historic Places is the Sawyer Farm, located on Maple Avenue in the town of Goshen. The farm contains a 16-room house and barns that have been in the Sawyer family since 1747. The homestead is one of the oldest farms continuously owned by the same family in the state.

This section of Scotchtown Avenue beyond the current football and baseball fields, shown in this 1930s photograph, was once considered part of the town of Goshen.

Eight
THE SALESIAN PROPERTY

This is the view from the corner of Main Street and Craigville Road.

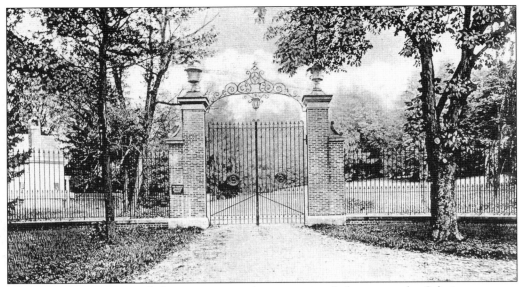

The Main Street gates and the entrance to what is commonly known as the Salesian property was the Haight estate in the 1800s.

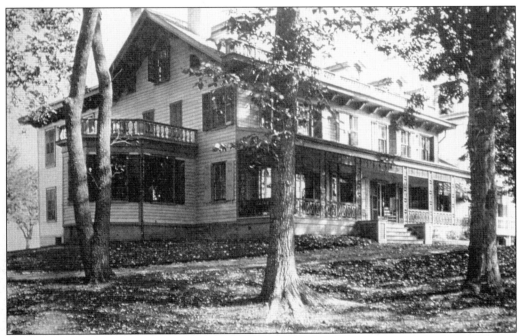

The main house was originally the family homestead of Mary Ellen Jansen, wife of David Henry Haight. Mary Haight inherited the property and named it Napknoll after her father, who was a Goshen doctor. The Haight family improved the property and made it their summer residence. David Henry Height was the father of Henry J. Height, and the grandfather of David Height. The photograph shows the original house that later became the main section of the Haight mansion.

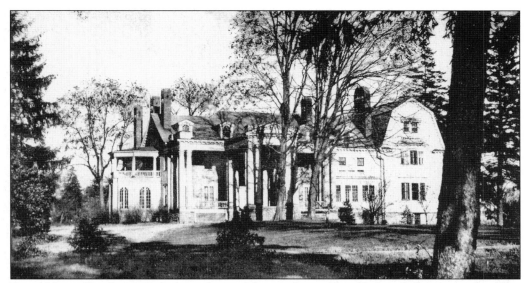

David Henry Haight was a dealer in hat and fur supplies in New York and also invested in New York real estate. He was a director of a bank and the Manhattan Life Insurance company. The Haight family estate was passed to John McCullagh, who called it LowWood Park. It then passed to Grant Hugh Browne, who named it Brownleigh Park. There was an attempt during this time to use the mansion as a veteran's rehabilitation center and a veteran's school, which met with little success. Browne's financial situation prevented the mansion from ever being used again as a private house. In 1925, the property was bought by the Missionary Society of the Salesian Congregation and the name Salesian has been associated with the property ever since.

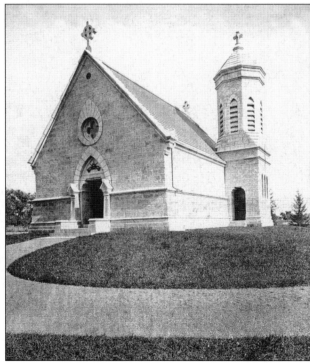

In 1872, David Henry Haight erected the mausoleum for the family. The structure is built of granite, has a marble floor and cost $75,000 in 1872. Haight died on April 29, 1876. His wife, Mary Haight, died on January 17, 1895. They had five children.

It was David Haight who laid out the drives and walks and constructed the lake.

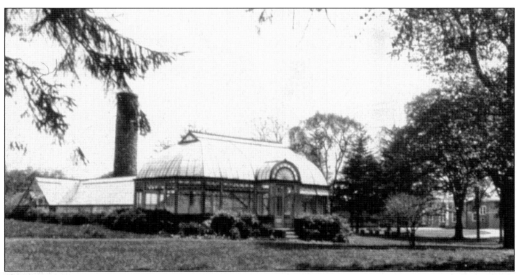

David Haight, son of Henry J. Haight and grandson of his namesake, improved the estate by building eight greenhouses after graduating from college in 1892. He propagated roses, palms, and violets.

102

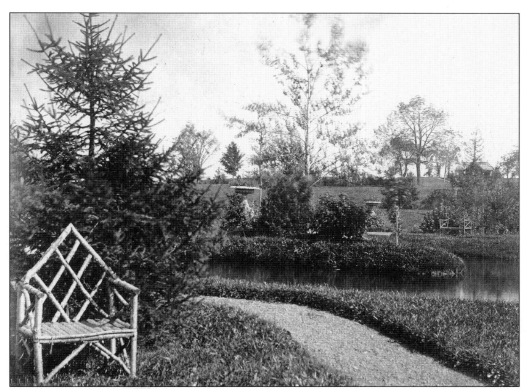

This photograph shows the extensive landscaping of the grounds during the Haight years of ownership.

David Haight also ran Napknoll Farm where he raised cattle.

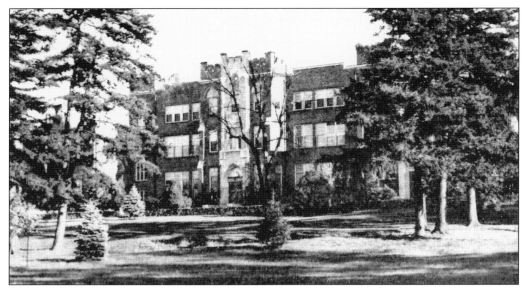

The school building constructed in 1925 for the education of seminary students is now vacant, and its future remains in doubt. The original 182-acre parcel has been subdivided with the Town of Goshen parcel in the hands of private developers, while the village parcel has been made into a park with both Village and Town of Goshen participation.

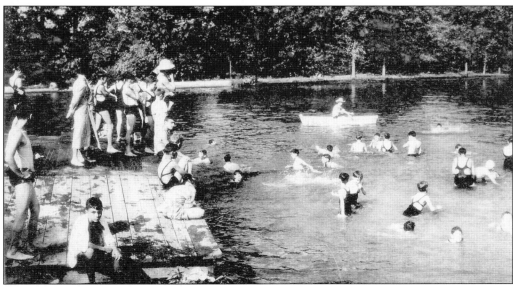

Children can be seen enjoying their morning dip in the pond behind the Salesian property school. The school and grounds were also utilized as a summer camp over the years.

Nine

THE INTERPINES

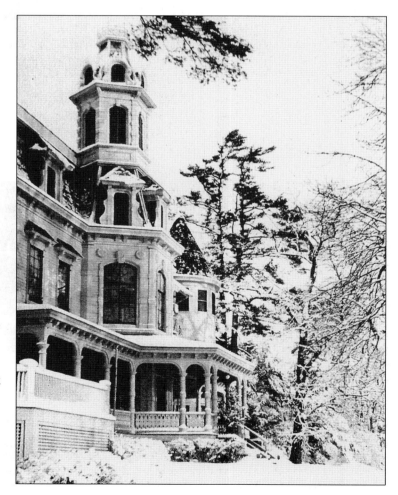

The Interpines was on the site of the Orange County Government Center. Gen. George D. Wickham built his house on the site when he sold his house, the Pines, across the street. In 1866, Robert H. Berdell, president of the Erie Railroad, bought the estate and remodeled this ornate Victorian house. The architect was E. J. M. Derrick from New York City. Derrick was also the architect of the Erie Railroad station. Robert Berdell left Goshen in 1876, and the house remained vacant for 18 years.

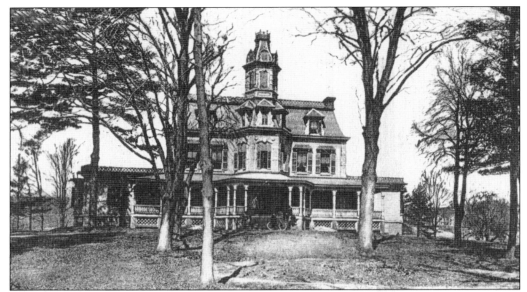

This imposing house was known as the Interpines. Dr. F. W. Seward Sr. opened his sanitarium on the site in 1889. In 1890, he added a wing to the house. It was intended as a general health care home but developed into a hospital for mental and nervous disorders. Following his death in 1925, his son Dr. F. W. Seward Jr. added a second building in 1926. The county purchased the house in 1964, and it was demolished to make way for the county government complex.

This is a view of the front porch when the house was Dr. Seward's sanitarium.

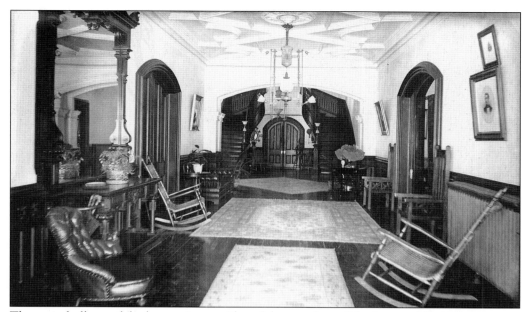

The main hallway of the house gives an idea of the grandeur of the house while in its prime.

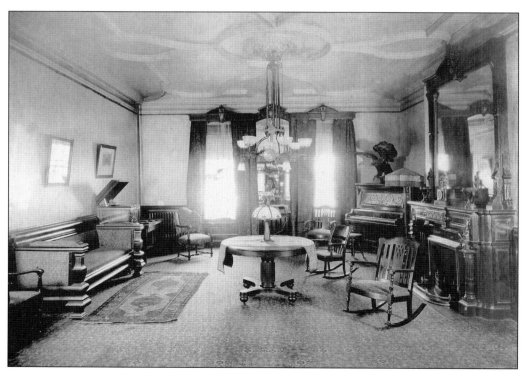

This is a view of the front parlor that was once used as the main dining room of the house.

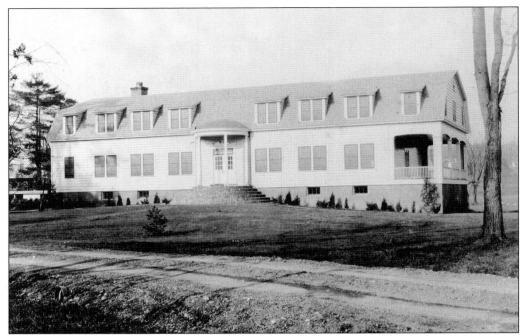

Known as the Cory Building this structure was built in 1926 as an annex for the Interpines Sanitarium operated by Dr. F. W. Seward Jr. The sanitarium could accommodate up to 70 patients. The building was razed in the 1960s to make room for the Orange County Government Center.

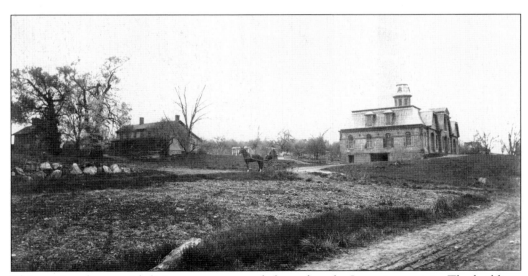

This carriage house with living quarters once belonged to the Interpines estate. The building, on Montgomery Street, was converted to a laundry by Andrew W. White. The building was destroyed by fire on December 15, 1996. The area around the carriage house was also the site of the Willow Crest Poultry Yard.

Ten

GOSHEN GONE

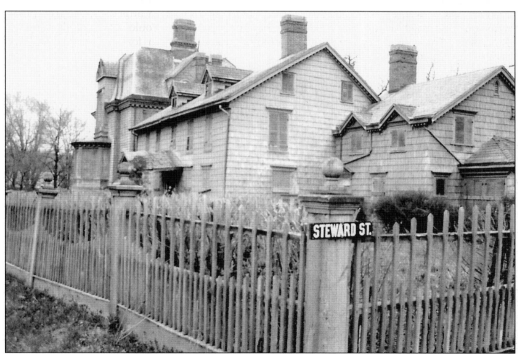

The Steward place was located on Route 17A near the Westgate Industrial Park on the site of the former Sorrento Cheese Company. The original section of the house dated to 1744 with the larger section built around 1865. The house remained in the Steward family until the house was demolished in the early 1960s. A family burial vault was removed prior to the property being sold.

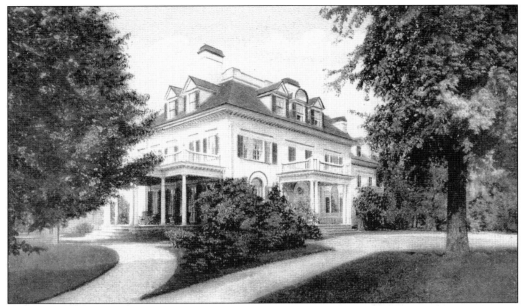

The imposing Campell Steward house in its glory days was located in the area of the current Route 17, the Quickway. It was known as the Hambletonian Inn for some years, before becoming a victim of its location.

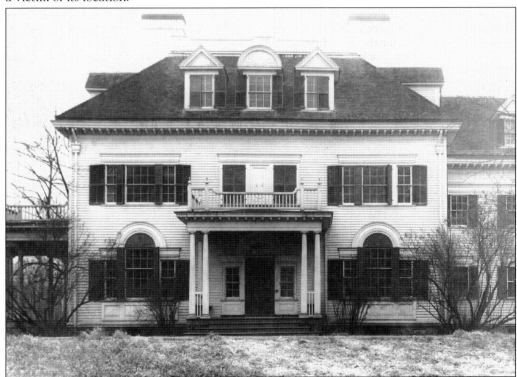

This photograph of the Campell Steward house was taken just before demolition of the house. The house stood in the way of the construction of Route 17.

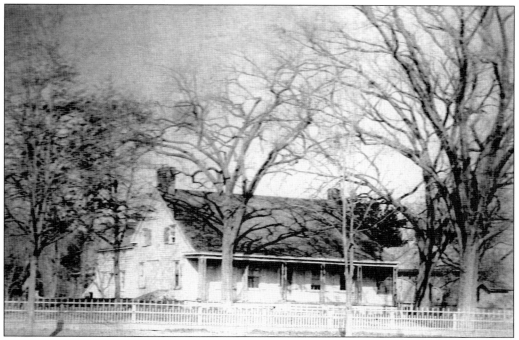

This is a rare photograph of the Gale-Wescott house that was erected in 1754 and demolished in 1878 to make way for the construction of the new Methodist Church. The house was an active homestead because of its central location for politicians, lawyers, and judges. For some time, it served as the rectory for the First Presbyterian Church. While similar in style to the current St. James' Rectory on South Church Street, differences can be seen in the rear wing and window treatments.

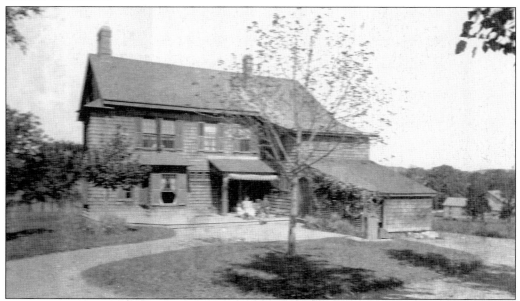

This house was a Coates family house that occupied a site near present-day Harriman Drive. The photograph shows the rear of the house.

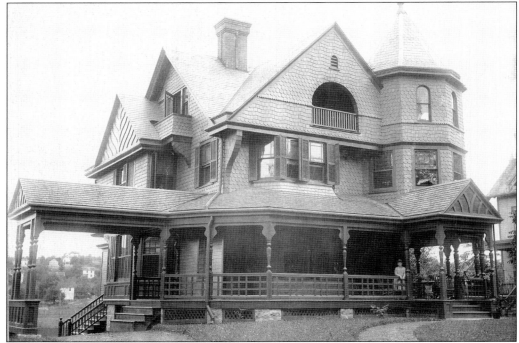

This beautiful Victorian home is no longer standing. It was built prior to 1900 on Main Street across the street from the Salesian property. A bank now occupies the site. The house was razed in 1975. The Morse family last occupied the house.

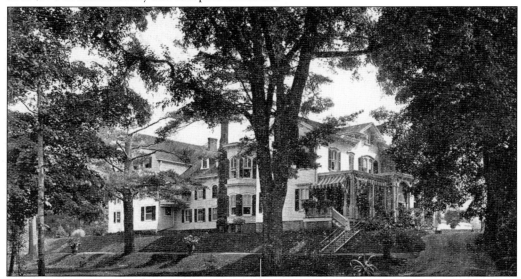

The Pines, an early homestead along Main Street that occupied the site of the Georgian brick house next to Maplewood, the village hall, was the site of an early inn and later the home of Congressman Henry Bacon and his wife, Susan Randall Bacon. Susan was active in local civic affairs and was instrumental in establishing the Goshen Hospital on Greenwich Avenue. After the Pines was destroyed by fire in 1916, the Bacons moved to the house on Hill Street behind the current Goshen Library.

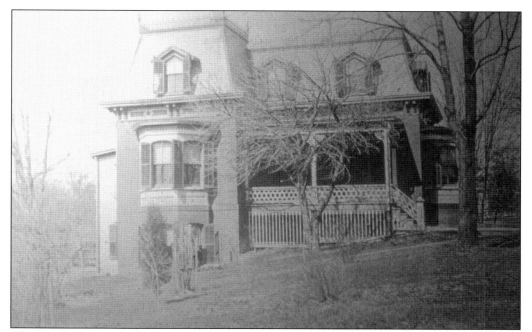

This unique Victorian stood on Murray Avenue next to St. John's School. It belonged to the Lewis family and lastly to the Gargiulo family before being demolished to make way for the addition of McCaffrey Hall to the school.

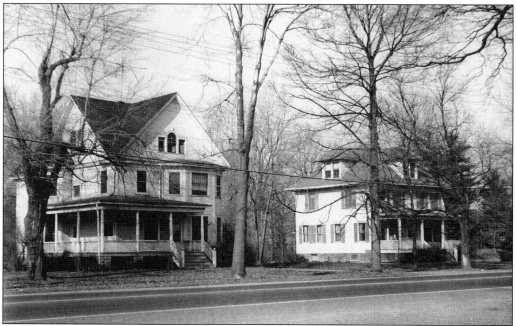

The homes of the Fitzgerald family (left) and Margaret Gleasey (right) were located on the corner of Main and Erie Streets. Margaret Gleasey owned Robinson's Stationery Store on West Main Street. Both buildings were used as county government buildings before being demolished in the 1960s to make way for the Orange County Government Center.

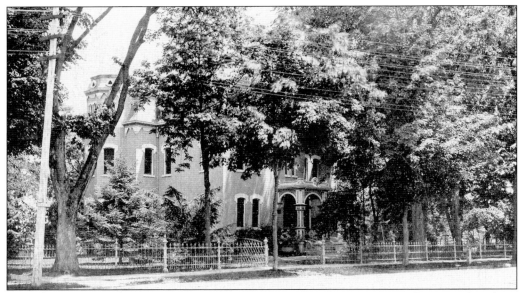

The above house was built by Capt. Ellis A. Post. The architect was C. H. Ackerman of Goshen. The house was also owned by Dr. John H. Thompson. In 1923, the First Presbyterian Church bought the house for church activities. The house was demolished in the 1960s.

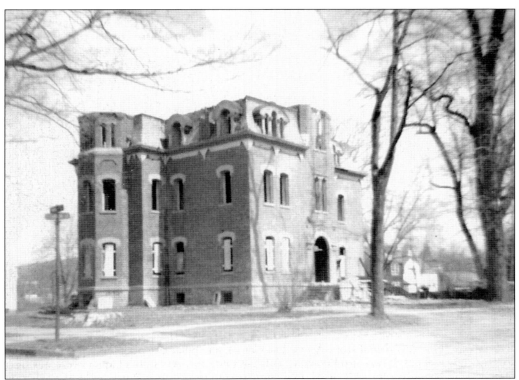

The Post-Thompson house is shown as it looked shortly before being demolished. The lot on the corner of South Church Street and Park Place is currently vacant.

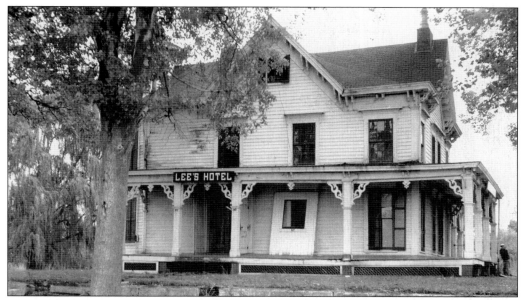

This house once stood on the corner of Route 17M and South Street. The large tree still standing on this corner was on the front lawn of this house. The house was built by Edmund Seely and owned by the Andrews family in the early 1900s. It was later converted to Lee's Hotel, a favorite place for horsemen who used to spend the summers in Goshen at the nearby Good Time Park and Historic Track. In the 1960s, the building was torn down and a service station was built on the site. In the 1980s, the station was removed, and an office building was constructed on the site.

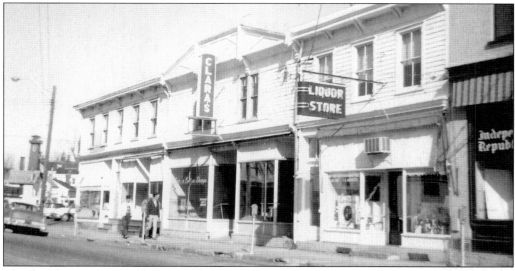

This building stood on the corner of Greenwich Avenue and South Church Street. The store on the corner was a jewelry store for years. Cliff Johnson was the last proprietor. The Goshen Bakery was along this row of stores, as well as Clara's, a popular stopping place for high school students after school. It was also known as Ada's at one time. Arvanite's Liquor Store was next door. The Independent Republican building was next to the Goshen Buick building farther up the block. All of the buildings were demolished to make way for the bank that now occupies the corner.

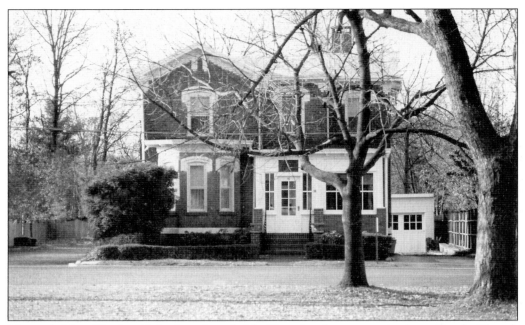

Mr. and Mrs. Charles Huber's unique brick Victorian house survived on South Church Street into the 1990s until it was demolished by the Goshen Savings Bank. The site is now a vacant lot.

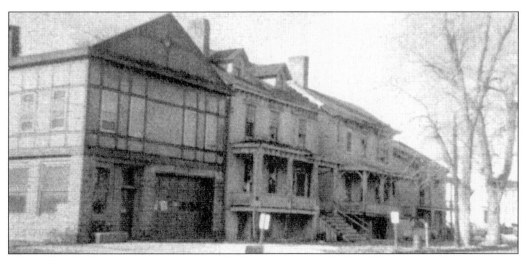

The Sutherlands operated a garage on the corner of South Church Street and Cross Street. School buses were housed there before the current bus garage on Scotchtown Avenue was built. The houses pictured were substantial homes in their day but fell on hard times and were razed, along with the garage, to make room for the bank currently on the site.

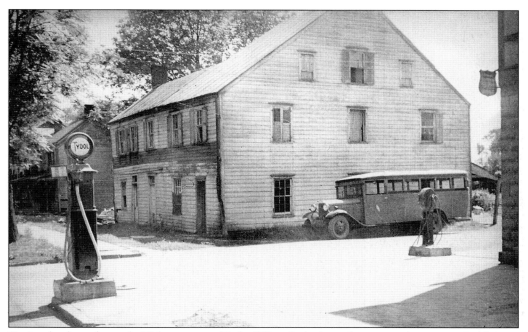

Dating back to the early 19th century, this building, in its later days, served as a rooming house. The building was razed in 1938 to make room for the Goshen Theatre.

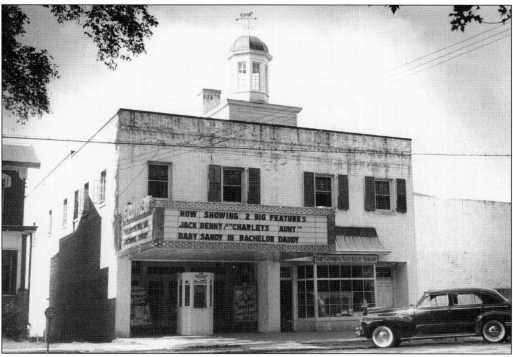

The Goshen Theatre was built by Carl and Walter Neithold and opened in 1939. The theater had a seating capacity of 832 people. The building was demolished in the 1980s for the construction of the drive-thru for the bank currently on the site.

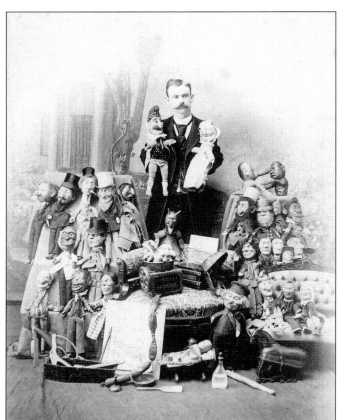

Clarence Augustus "Gus" White was an artist and puppeteer who was born February 6, 1859. His first puppet show took place in 1878. His last show was in Goshen in 1931. His Punch and Judy show was a popular attraction at Midway Park, an amusement park between Goshen and Middletown. White died March 2, 1934. His puppets, stage, scenery, props, and ticket booth were sold as a complete collection, at a well-attended auction conducted by the Mark Vail Auction Company in Pine Bush, New York on October 24, 1992.

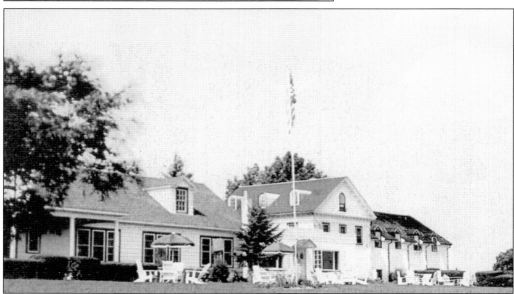

The Eureka Steak house, originally a private estate, beyond the current Elant and Arden Hill Hospital complexes was a popular restaurant for years. It later became a night club called Mother Goose, and various named restaurants before being destroyed by fire in the 1970s.

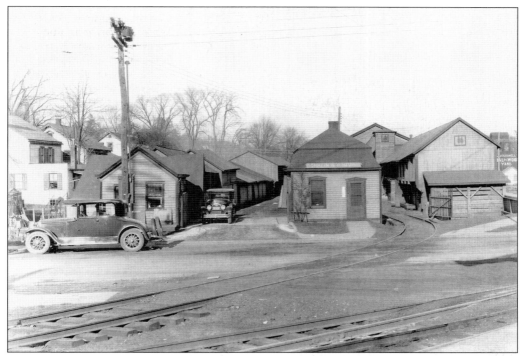

Conklin and Cummins was a lumberyard along Grand and Canal Streets dealing in the early 1900s in feed, hay, straw, lime, cement, and coal. It was preceded by the N. C. Sanford Lumber Yard in the late 1800s.

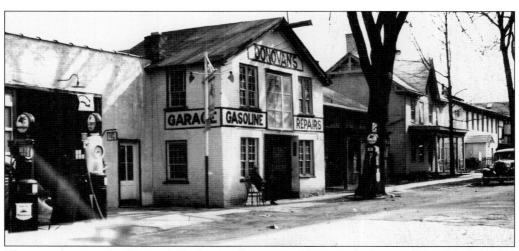

This is a photograph of Donovan's Garage that was on Greenwich Avenue. The garage was on the site of the current beer distributor and the bagel shop. The brick house was the Vavricka home for many years. The building in the distance was the location of the cheese factory and Pies-On pizza restaurant. The building was destroyed in a fire. The lot is currently vacant.

Burt's Atlantic service station was located on the corner of North Church Street and Montgomery Street. A Victorian house occupied the site before its demolition to make way for the service station. The building was modified to serve as the bank that now occupies the site. The former Mackey home is in the background.

The Goshen Buick building occupied the Greenwich Avenue site now used as a village parking lot behind the bank building on the square. The building extended from Greenwich Avenue to Cross Street in the rear. The Erie Railroad ran along the side the building, and its roadbed is now used as part of the Heritage Trail.

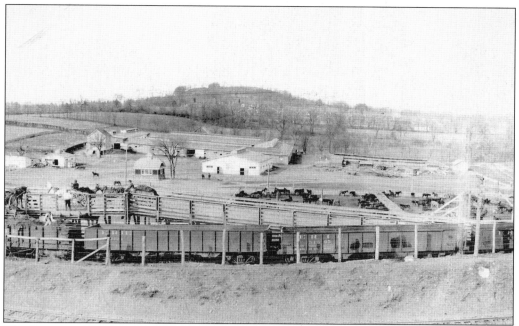

The Leprestre Miller Stock Farm opened in April 1916. It was located on South Street behind the current Paddock condominiums. The house Elm Lawn, which still stands, served as the office and living quarters for the farm. The farm's purpose was to care for horses and mules purchased by the Royal Italian Remount Commission for use in World War I. The farm was a relay station for animals shipped from the west in advance of being shipped to Italy. The last horses left the farm in 1919.

On the Leprestre Miller Stock Farm were three complete and independent watering systems with a storage tank that had a capacity of nearly 100,000 gallons. Pictured is the reservoir building that was the last farm building standing.

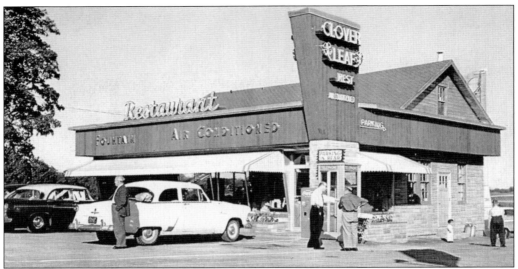

A popular stopping place for travelers on Route 17, the Clover Leaf Restaurant was on Route 17A and Greenwich Avenue next to the current Mobil Station.

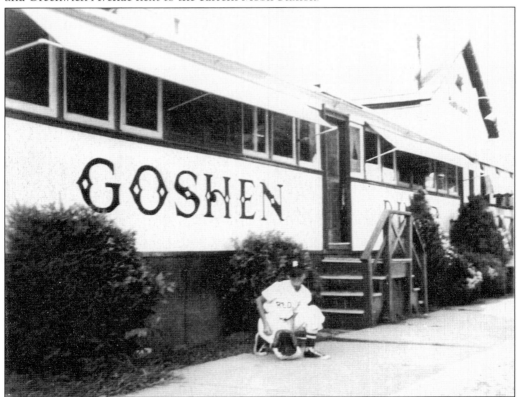

Spadie Weeden is seen in his Little League Red Sox uniform in front of the Goshen Diner that was operated by his parents. The diner stood on Main Street across from the park between the Wilcox building and the flat iron building on the corner of Webster Avenue. The diner was replaced by a "modern" diner known as Cy's Diner. The site is now a parking lot.

The Orange County jail stood on Erie Street behind the Orange County Government Center. The jail was demolished, and the site is currently vacant. The new jail on 6½ Station Road replaced this building.

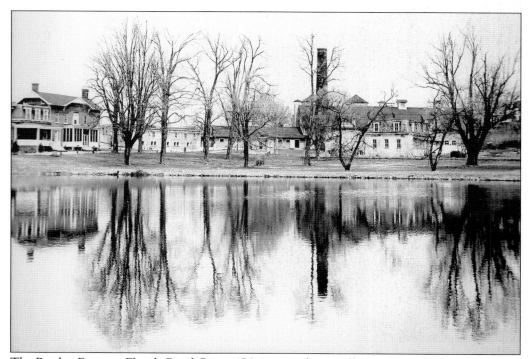

The Borden Farm on Florida Road, Route 17A, was used as a milk processing facility for farmers. It was the Howell family homestead for years. The farm contained an imposing Federal brick house and many barns and buildings that survived into the 1960s.

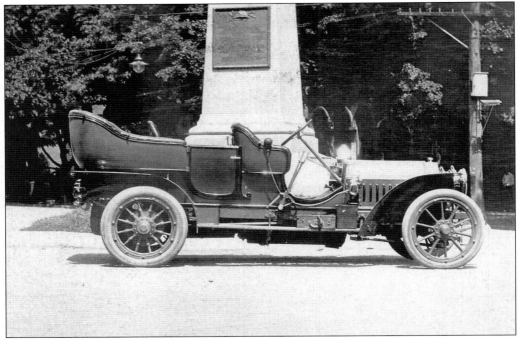

The Coates-Goshen car is displayed in front of the Orange Blossoms Monument on Main Street.

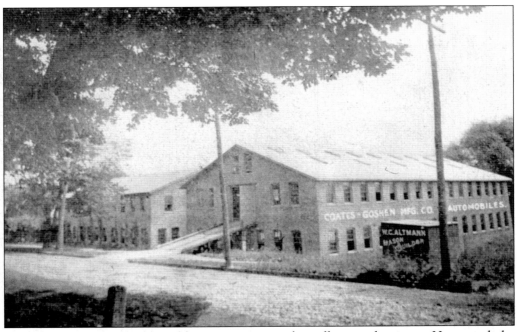

Joseph Coates was a builder of harness racing tracks, sulkies, and wagons. He started the Coates-Goshen Manufacturing Company on Greenwich Avenue in 1908, where he built automobiles. The site today is the Healey Brothers car dealership.

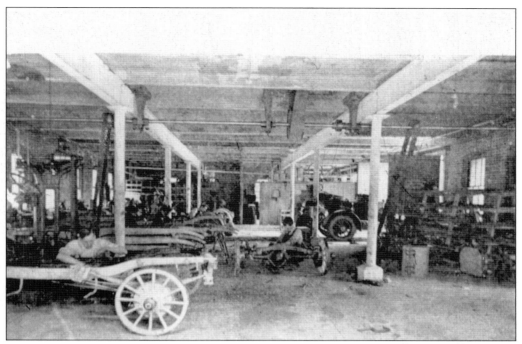

This photograph is an interior view showing the manufacturing of the Coates-Goshen automobile. The business could not compete with the assembly line production of Ford and other manufacturers and the business gradually faded away.

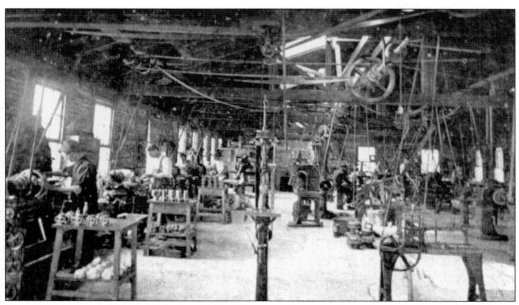

Another photograph of the interior of the Coates car factory shows the individual work stations for the manufacturing of the parts for the Coates-Goshen automobiles.

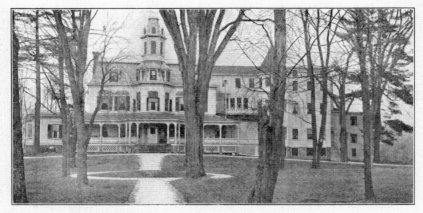

"INTERPINES" located in the village of GOSHEN, N. Y., was established by Dr. F. W. Seward in 1890 and has become well known as thoroughly reliable, dependable and ethical. It is beautiful, quiet, restful and home-like and the accommodations are of superior quality. Disorders of the nervous system are made a specialty. During the past three years many cases have been successfully treated in open air tent-bungalows erected on the grounds at "Interpines."

At Chico, New Mexico, Dr. Seward has a ranch of several thousand acres. The climatic conditions there are perhaps the best, the very best, to be found in the whole United States and for a number of years Dr. Seward has sent many cases of malnutrition, retarded development, nervous exhaustion, etc., there and never has there been a disappointing result.

There is a good deal to be said in regard to the selection of cases for climatic treatment. Climate is a positive and all potent remedy for many conditions of ill health, but like all other remedies is only applicable in certain cases and must be intelligently applied by those familiar with its effects. When so applied the results are satisfactory and ofttimes surprising.

DR. F. W. SEWARD, Sr.
DR. F. W. SEWARD, Jr.
 Goshen, New York

Phone 117 Goshen

This is an advertisement for the Interpines.

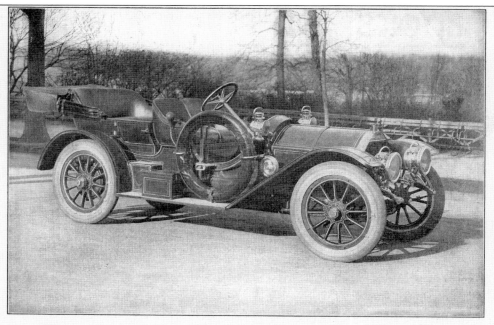

The "Coates-Goshen" Cars

DETACHABLE BABY TONNEAU (very roomy)

The above picture tells its own story of refinement in design and finish. This is a strictly high-grade car (chassis as well as body) that will hold its own with the Best.

Roomy Bodies (our own make). From Runabouts to Limousines.

32 H. P. Model—116″ Base.	45 H. P. Model—123″ Base.
Engine—4-Cy., water-cooled, 4½x5.	Engine—4-Cy., water-cooled, 5x5¾.
Wheels—Demountable rims. Tires 36x4.	Wheels—Demountable rims. Tires 36x4½.
Transmission—3 speeds selective, chrome nickel gears, H. B. bearings, shaft drive.	Transmission—3 speeds selective, chrome nickel gears, H. B. bearings, shaft drive.
Bosch Magneto.	Bosch Magneto.
PRICE, $2850	**PRICE, $3250**

N. Y. Office: Hotel Marie Antoinette—Tel. 2740 Col.

GEO. W. FLOYD, New York Agent

COATES - GOSHEN AUTO CO.

GOSHEN, N. Y.

Please mention The Automobile when writing to Advertisers

Pictured here is a Coates-Goshen car advertisement.

ACROSS AMERICA, PEOPLE ARE DISCOVERING SOMETHING WONDERFUL. *THEIR HERITAGE.*

Arcadia Publishing is the leading local history publisher in the United States. With more than 3,000 titles in print and hundreds of new titles released every year, Arcadia has extensive specialized experience chronicling the history of communities and celebrating America's hidden stories, bringing to life the people, places, and events from the past. To discover the history of other communities across the nation, please visit:

www.arcadiapublishing.com

Customized search tools allow you to find regional history books about the town where you grew up, the cities where your friends and family live, the town where your parents met, or even that retirement spot you've been dreaming about.